HOW TO BE A RULE-BREAKING LETTERER

HOW TO BE A RULE-BREAKING LETTERER

A GUIDE TO MAKING PERFECTLY IMPERFECT ART

by Huyen Dinh

CHRONICLE BOOKS
SAN FRANCISCO

Library of Congress Cataloging-in-Publication Data:
Names: Dinh, Huyen, author.
Title: How to be a rule-breaking letterer : a guide to
 making perfectly imperfect art / Huyen Dinh.
Description: San Francisco : Chronicle Books, 2023.
Identifiers: LCCN 2022032770 | ISBN 9781797215532
 (paperback)
Subjects: LCSH: Lettering—Technique.
Classification: LCC NK3600 .D56 2023 |
 DDC 745.6/1—dc23/eng/20220719
LC record available at https://lccn.loc.gov/2022032770

Manufactured in China.

Design by Huyen Dinh and Kayla Ferriera.
Chapter 9 photos by Dung Vu.
Typeset in Circular Pro, Wildside, and Lava Lamp.

10 9 8 7 6 5 4 3 2 1

Chronicle books and gifts are available at special
quantity discounts to corporations, professional
associations, literacy programs, and other
organizations. For details and discount informa-
tion, please contact our premiums department
at corporatesales@chroniclebooks.com
or at 1-800-759-0190.

Chronicle Books LLC
680 Second Street
San Francisco, California 94107
www.chroniclebooks.com

TO ALL MY IMPERFECTIONS,
YOU MAKE THIS BOOK.

CONT

RULES ARE MADE TO BE BROKEN

- DOUGLAS MACARTHUR

FOREWORD

THE RULE

A foreword is written by someone other than the author and tells the readers why they should read the book. That person is usually an expert in the field or a celebrity.

LET'S BREAK THE RULE

A foreword is written by the author, a.k.a. ME. To be honest, I'm a first-time author, so not many people in the field know me. I don't know any celebrities either. But I'm an expert at breaking the rules and embracing imperfection, so I'm qualified.

To everyone who bought this book, keep reading to discover how to become an expert rule-breaker yourself.

INTRO

MY STORY

"Your handwriting is bad; you won't be successful if you don't fix it," said my middle school teacher. Looking back, I'm not sure how those two factors are related, but as a kid, I just listened. Growing up in Vietnam, I was pretty much required to be a good girl.

What does it mean to be a "good girl"? A good girl is a people pleaser, obedient, excellent at following rules, and most of the time doesn't have opinions on things. Having good grades (a.k.a. As or above) and doing the right thing are musts.

I was that good girl for my whole childhood in Vietnam, and the role continued when I moved to the United States for high school. With more than twenty years of experience following what society wants, I think I deserve the good girl gold medal.

After getting a degree in graphic design, I had stable jobs at different big corporations. I did everything I was supposed to do based on social norms, so why did I still feel unfulfilled? I never fit in at any job.

That was when I found my passion for lettering, the creative outlet that let me freely explore my voice as a person and an artist. The calling was so strong that it gave me the courage to quit my job. "Quitting a stable job to start your own business

from the ground up at the age of thirty rather than settling down (a.k.a. marriage and kids), are you cray?" That was what I thought people would tell me when I shared my decision. Luckily, my friends, family, and even my former manager were all very happy for me to take the leap. It was time for me to quit the good girl role—the unrealistic, perfect role that society demands—and pursue what I WANTED for ME in my life.

I will sprinkle my artistic journey throughout this book so you can see how I have embraced my imperfect lettering style.

This is not just any lettering book but is written by an over-thinking Viet artist who has learned ways to break the rules. If this idea resonates with you so far, keep flipping.

Dear Good Girl Role,
I quit!
Sincerely,
Me

2008

When I was twenty, my college counselor advised me to stick with an accounting major since I would make more money as an accountant than a designer. I changed my major anyway.

My takeaway: You can make money doing anything if you have a passion for it and are good at it.

2011

I was told that my portfolio was not diverse enough to get a good job, but I ended up getting an internship at one of the biggest entertainment companies and moved to Los Angeles.

My takeaway: Don't listen to the people who say you can't do something.

2012–2015

I worked for big consumer products corporations and got laid off or fired four times.

My takeaway: Sometimes you don't suck; the jobs are just not the right fit.

2016–2019

I was very unhappy with my full-time job but held on to it anyways. I experienced my first panic attack while driving to work. I decided to choose myself and quit my job right away.

My takeaway: Listen to your body. Your mental health is the priority; no money can buy it.

2020

I pursued my career as a full-time lettering artist with the support of friends and family.

My takeaway: When you have passion for what you do in life, you always wake up with a purpose.

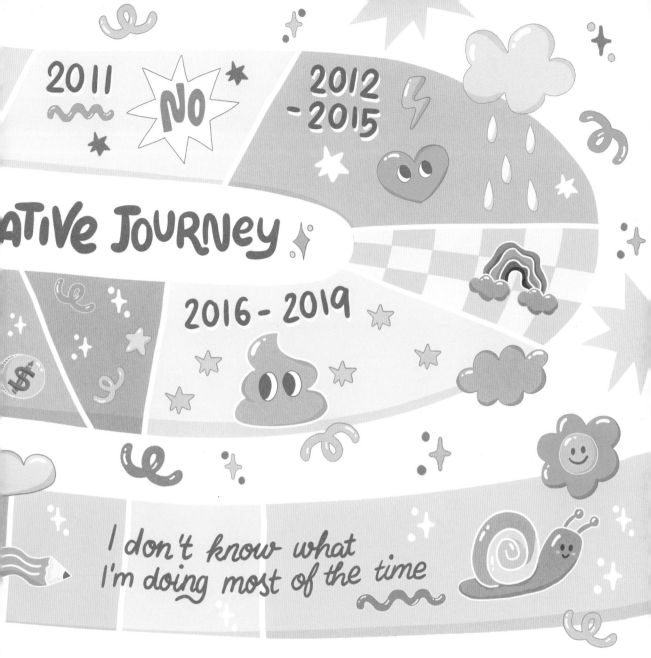

2021

I'm here writing a book for you about how to break lettering rules and make your own.

2022–present

The truth is I don't know what I'm doing most of the time, but everything is figure-out-able as long as you put your mind to it. Thanks for being here with me and allowing me to cheer you on throughout your creative journey.

TO MY READER

(yes, you, the one who is holding the book now),

Let me be honest with you: The point of this book is not to teach you how to draw perfect lettering or give you a cookie-cutter method to follow.

Say what? A lettering book that doesn't make me the best artist? What's the point then?

I'm glad you asked; see, I can read your mind already. We will get along just fine.

This book will teach you the foundation of lettering and all the rules you need to know so you can then break them like an artist. Why should you break the rules, though? We are taught to follow rules the moment we are born. Be a good kid, and Santa will reward you. It's not surprising that we apply that habit to learning new skills.

Have you ever wanted to try a new skill? "There are already so many talented people out there. Why should I start now?" your inner voice whispers. The good thing is you don't need to listen to it. Tell your impostor syndrome to take a chill pill.

Let's get back to us. The truth is, there will always be enough space for you and your talent. You just need to give your inner artistic voice a chance to speak louder than your doubts.

Imagine if we all used the same exact rules to create; we would end up with identical results.

The most famous artist who is known for breaking rules is Pablo Picasso. He learned one of the rules of art, the illusion of volume, and then slowly broke it by flattening his elements. It was so

controversial that he hid his painting *Les Demoiselles d'Avignon* for nine years before showing it at an exhibition. The rest is history.

Rules are made not to rule us but to be bent and broken. By breaking selective rules for the right reason, you can create something YOU-nique.

As you'll find out as you read my story, I used to have a squeaky-clean record of being a good girl. I spent many years growing from a rule-following, people-pleasing little girl to a rule-breaking, speak-your-mind badass. That's why I wrote this book for you, to help you gain your creative confidence, embrace your perfectly imperfect self, and step out of your comfort zone to try new things.

By the end of this, you might not be the "best of the best" letterer, but you will have learned how to find your way to a "that's so you" style.

The secret to navigating your journey is not to use any shortcuts but to practice, practice, and practice (if I can repeat this more, I will). Creative muscle takes time to develop. Don't give up too early, before you even make progress, and remember, progress over perfection.

Bonus point: You can totally show off your awesome lettering skills in fun DIY projects, like greeting cards, name tags, and so much more.

Ready to be a rule-breaking letterer with me?

Love + a hug (you can't feel it, but it's there),

Huyền Đinh

a.k.a. Pink Specialist

AFFIRMATION FOR A POSITIVE MINDSET

Before starting your creative journey, let's strengthen your mindset. We all struggle with impostor syndrome, and that's totally normal. There might not be a way to get rid of it completely, but we can learn how to rewire our brains. Every time you need a reminder, this note will be here for you:

Dear artists,
Your art may not change the world.
But it simply does matter,
Because if you can change one person's day,
That person can change another person's day.
And just like that,
The world can be a better place
Because of you.
Everything is connected.
You might not see a direct impact,
But indirectly, you make a difference.
Even if it's a tiny difference,
It still counts.

We need your creations in this world.
Your creative journey is just beginning.
Keep creating, my friend!

CHAPTER 1

- Uses of lettering

- Lettering and feelings

- Lettering vs. calligraphy

Lettering is everywhere, if you pay close attention. It's on the milk carton you drink from and the signs of the stores you pass on the street. It's on the phone case that you carry every day and the books stacked on your shelf. It's on the mural you like to take photos in front of with your friends and family. They all feature lettering but in different shapes and forms.

USES OF LETTERING

Lettering applications are very versatile. Because lettering is tailored to each project, it helps brands grab consumers' attention. Here is some work I've created for clients over the years.

MURALS

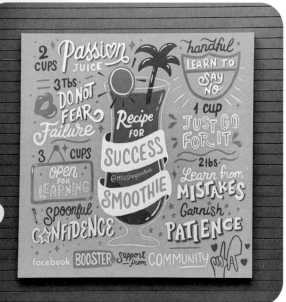

Facebook's dinner event

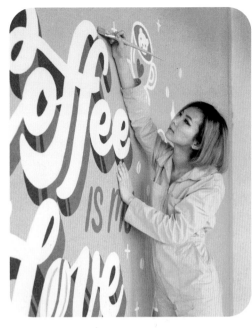

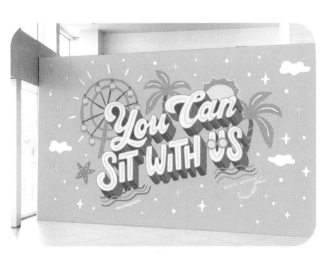

Coffee World Museum in Torrance, California

Santa Monica Place Mall in Santa Monica, California

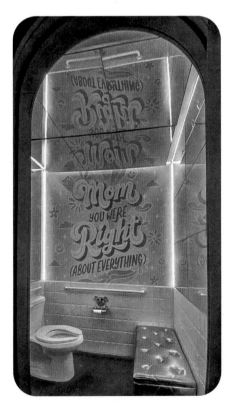

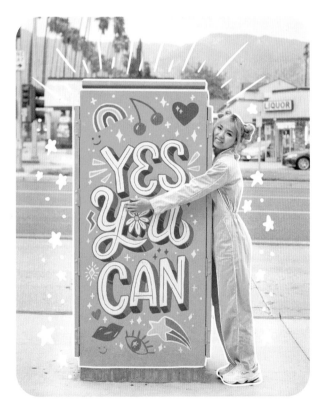

Tran An restaurant in Miami

Utility box in Glendale, California

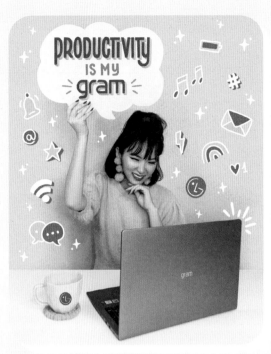

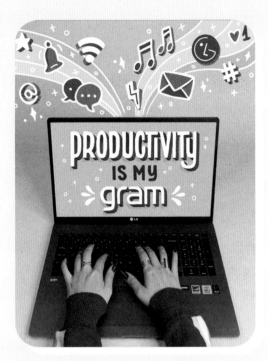

LG Gram laptop campaign

ADVERTISING CAMPAIGNS

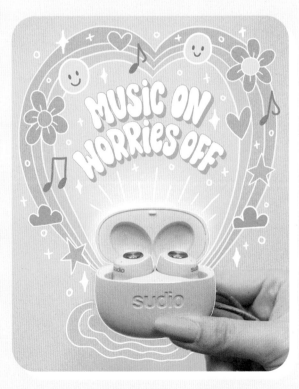

Sudio's earbuds campaign

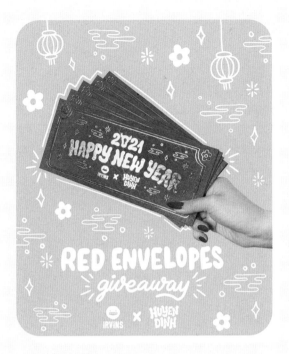

Red envelope for Irvins

Stickers for Canon Mini Print app campaign

Lettering can be used to create fun merchandise as well. Here are some products from my online store, shop.huyendinh.com.

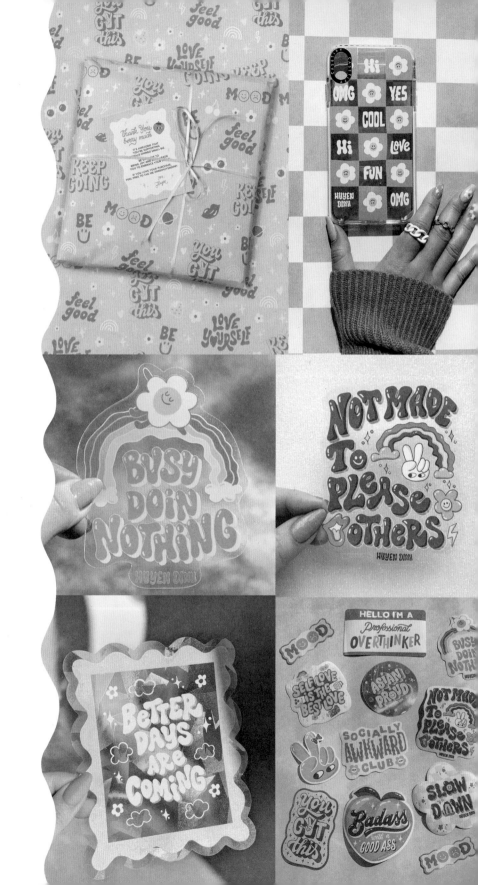

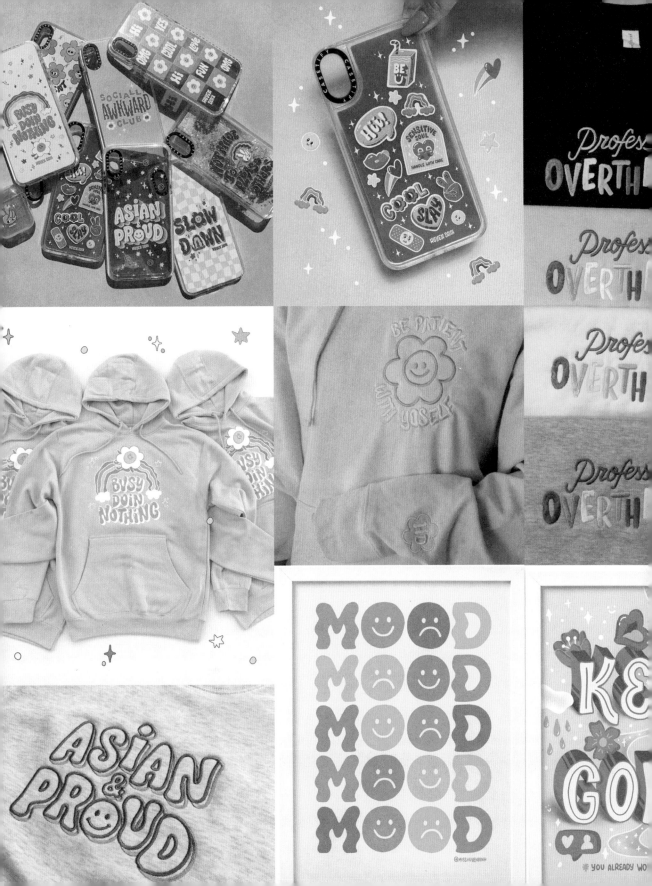

IT'S OK TO NOT HAVE ANSWERS for it EVERYTHING IT WILL all MAKE PERFECT SENSE SOME DAY (JUST NOT TODAY) till then KEEP GOIN

LETTERING AND FEELINGS

Lettering is a beautiful combination of design and words. It is not only a pretty visual but also has its own story to tell. How the letters are drawn can evoke deep emotions in viewers. I use lettering as a way to journal and express my feelings.

The style you choose for lettering matters because it will give off a certain mood.

SASSY MOOD

NOT MADE TO PLEASE OTHERS

Badass with a GOOD ASS

QUIRKY MOOD

HAPPY MOOD

LETTERING VS. CALLIGRAPHY

Before jumping into how to learn lettering, let's talk about these basic terms that are often used interchangeably and can be confusing to people who don't have much experience with them. Lettering and calligraphy are both art forms relating to letters, but they don't have the same meaning.

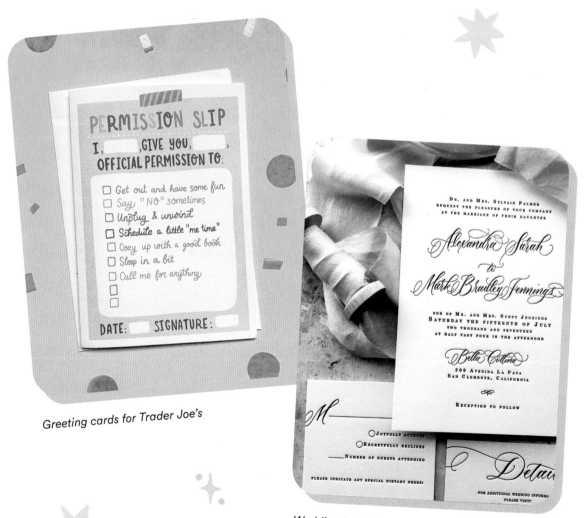

Greeting cards for Trader Joe's

Wedding invitation by Angelique, Ink.

LETTERING CALLIGRAPHY

	LETTERING	CALLIGRAPHY
Definition	Draftsmanship: The art of **drawing letters**	Penmanship: The art of **writing letters**
Basic Tools	PENCIL INK PEN BRUSH PEN MARKER ERASER	OBLIQUE PEN AUTOMATIC PEN RULING PEN POINTED BRUSH INK
Method of working	The artist produces the weight of a letter by drawing as many strokes as needed. You can erase and change the letters until you're happy with the result. In lettering, the letters are unique for each project.	The artist produces the weight of a letter by using pressure in a single stroke. There is no erasing and correction after the letters are done. In calligraphy, the letters have set styles.
Artist titles	Letterer	Calligrapher
Some typical applications	Add a personal touch to greeting cards, gift tags, tote bags, journals, jar labels, and more.	Create wedding and event invitations, logos, letters, etc.
End result		

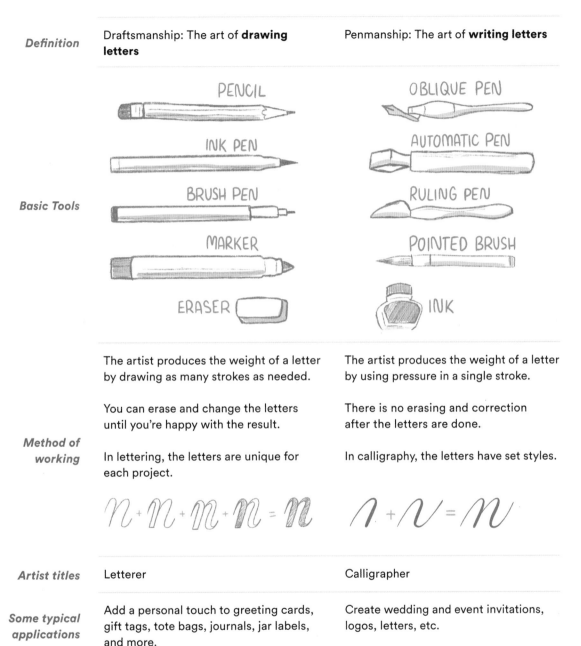

The tools an artist uses might be an indicator of the art form, but they do not define calligraphy or hand lettering. What sets these two apart is the process of how letters are created:

Lettering is the art of **drawing letters**.
Calligraphy is the art of **writing letters**.

Now that you understand the differences between lettering and calligraphy, are you still wondering which one to go with? Don't worry, there is no wrong choice. It really depends on your unique skill set and which process you enjoy more.

Lettering is my go-to choice because every letter can be customized to fit my artistic vision. It will add more personality and uniqueness to my final piece. Plus, I'm a professional overthinker, so I go back over my sketches a million times (well, maybe ten times) to improve the piece as much as I want.

✦. NOTE ✦.

Did you know that lettering is not considered handwriting? Handwriting is simply how you write (a note or a grocery list) for functional purposes, when the writing doesn't need to be pretty. I'm good at lettering, but my handwriting looks like this:

Ta-da! Are you surprised? You really don't need to have pretty handwriting to be good at lettering. It takes practice and discipline to get better at lettering; it's all about muscle memory.

KEY TAKEAWAYS

Lettering is the art of drawing letters.

Calligraphy is the art of writing letters.

Can you imagine yourself living in a foreign country without knowing the language? Of course you could survive, but you would have trouble expressing yourself and communicating with other people.

I know that feeling so well. I moved to the United States at the age of fifteen. The two words I used the most were "Yes" and "No." I didn't have enough vocabulary to hold conversations with anyone. I was also scared that people would make fun of my accent. And you know how that goes in high school, especially when you transfer to a new school in your senior year: sitting alone at your "own table" in the cafeteria.

Enough sad stories. I brought this up not so you would feel bad for me, but to emphasize the importance of learning another language.

After countless nights reading magazines aloud and imitating reporters on TV, I found the courage to speak English to others, even though it wasn't perfect. It was worth the effort because now I'm sitting here and writing a book about embracing creative imperfection for you.

It's the same with lettering. Before jumping straight into that world, you need to learn its language. Then you can hold meaningful conversations about letters instead of calling this or that "thingy." Knowing basic terms can help you improve your work during a design critique or have a better chat with a fellow lettering friend.

LET'S LEARN LETTERING LANGUAGE!

GUIDELINES

Guidelines are important and helpful to the process when you start learning lettering. They keep all the letters uniform and help you figure out the size and shape of the letterforms. There are five types of guidelines. You will learn how to break the rules and not use them in chapter 6.

Ascender line
The line that marks the height of ascenders. Sometimes the ascender line can be the same height as or taller than the cap height.

Cap height
The line that measures the height of uppercase letters.

X-height
The height of lowercase letters, using the character x's height as the standard.

Baseline
The line all the letters sit on.

Descender line
The line that marks the height of descenders.

ASCENDER / CAP HEIGHT

BASELINE

X ↕ X-HEIGHT

DESCENDER

Ascender
Any part of lowercase letters that extends above the x-height.

Descender
Any part of lowercase letters that extends below the baseline.

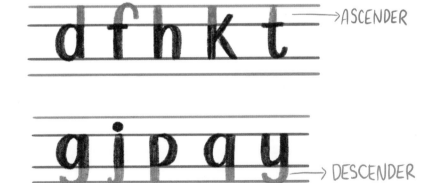

d f h k t →ASCENDER

g j p q y → DESCENDER

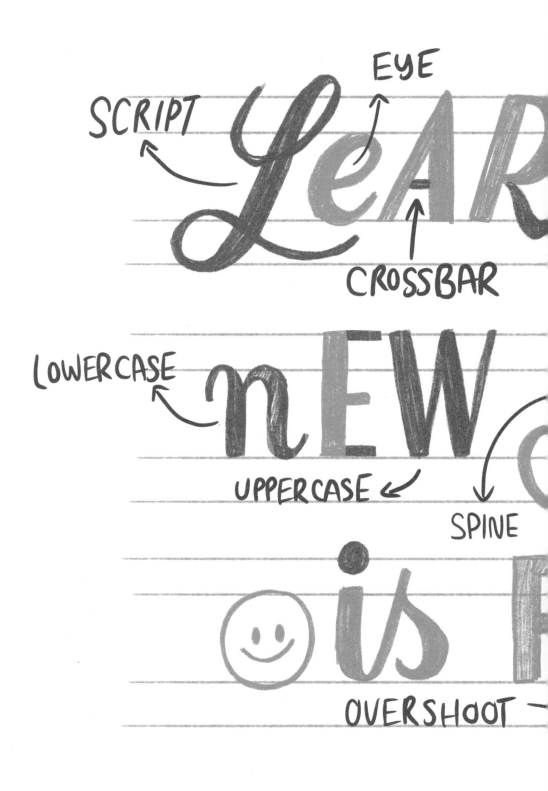

SCRIPT

EYE

CROSSBAR

LOWERCASE

UPPERCASE

SPINE

OVERSHOOT

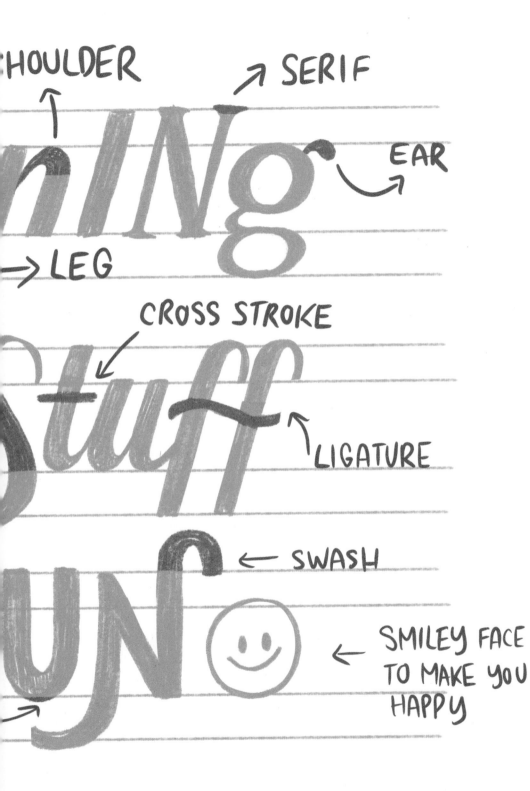

SHOULDER

SERIF

EAR

LEG

CROSS STROKE

LIGATURE

SWASH

SMILEY FACE
TO MAKE YOU
HAPPY

THE ANATOMY OF A LETTER

There is a lot more lettering terminology, but I just want to highlight some basic terms I personally use that would be helpful for you to start with.

STROKES

The components of a letterform. Strokes can be straight, as in *k*, *l*, and *v*, or curved, as in *c*, *o*, and *s*. A series of strokes makes up a letter.

LIGATURE

Two or more letters combined into one character.

SWASH

A decorative element that extends one of the strokes of a letter.

BOWL

The fully closed, rounded part of a letter.

CROSSBAR

The horizontal stroke that connects two sides of a letterform.

CROSS STROKE

A horizontal line that extends across *t* and *f*.

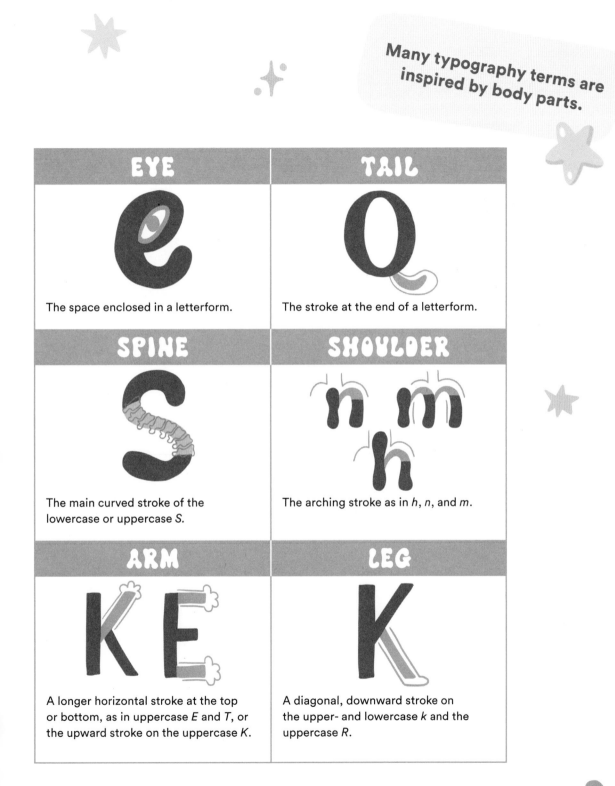

EYE

The space enclosed in a letterform.

TAIL

The stroke at the end of a letterform.

SPINE

The main curved stroke of the lowercase or uppercase *S*.

SHOULDER

The arching stroke as in *h*, *n*, and *m*.

ARM

A longer horizontal stroke at the top or bottom, as in uppercase *E* and *T*, or the upward stroke on the uppercase *K*.

LEG

A diagonal, downward stroke on the upper- and lowercase *k* and the uppercase *R*.

LETTERING STYLES

Let's talk style! There are so many different lettering styles, and you might find them overwhelming when you're a beginner. However, finding your own style takes time, so knowing these basic styles can be a good starting point.

SANS SERIF

Sans serif means "without serif." Sans serif type has a clean and contemporary feel.

NO SERIF
=SANS SERIF

SERIF

A serif is a small line attached to the end of the stroke.

Although it is tiny, there are so many different ways to be creative with it.

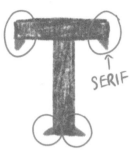

SERIF

nnnn

ENOUGH Peachy

ENOUGH Peachy

ENOUGH **Peachy**

KIND KIND KIND

BRUSH SCRIPT

Brush script imitates calligraphy by using a brush pen. With each letter, heavy pressure is applied on the downstrokes, and light pressure is applied on upstrokes. There are more brushstrokes terms, but I want to highlight these four basic brushstrokes to help you draw brush script lettering and identify which stroke is thin or thick.

Upstrokes
Thin stroke, light pressure with the brush pen.

Downstrokes
Thick stroke, heavier pressure with the brush pen.

Overturn strokes
Thin upstroke, transition to thick downstroke.

Underturn strokes
Thick downstroke, transition to thin upstroke.

Now you can apply the thick downstroke and thin upstroke to draw letters.

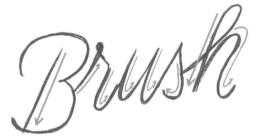

SCRIPT

This is one of the most popular lettering styles where all the letters connect to each other. It is loosely based on handwriting.

LETTERING STYLES CAN CHANGE THE MOOD OF THE WORD OR PHRASE.

This round brush script style has a bubbly vibe.

This thick curved serif style has a traditional and classy vibe.

This bold sans serif style has a modern vibe.

This script style has a cute vibe.

"THAT'S SO YOU" STYLE

As you start your artistic journey, don't rush to find *your style* right away. Focus on your artistic voice instead: what kind of message you want to communicate with the world. Your style will come naturally at the right time.

Finding your style is not a "happy ending" but simply a step along your creative journey. Your personal style will evolve over time, and that's the beauty of growth. You gotta trust the process and follow your gut. You don't need to know everything to start.

Start where you are, with what you have. Everything is figure-out-able as you go.

2014

My first ever lettering pieces with marker. Don't laugh at me. We gotta start somewhere, right? I gave up because I thought I wasn't good enough.

2017

I decided to give lettering a try again. I used mostly marker and pencil at this point.

2018

I was pretty shy about using colors, so I played it safe with black and white.

This is the first piece I posted on my social media.

This is my first digital lettering piece using Procreate.

Let me walk you through how my style evolved throughout the years. You don't have to stick with one style if you find one; it's OK to experiment with different styles.

2019

Then I tapped in one- to two-color schemes. Script and swashes were my jam back then.

I challenged myself by lettering longer phrases.

I started using more colors (two to three colors per piece) and added dimension and detail to my lettering. My lettering still stayed within the guidelines, but I let my sassy voice shine more.

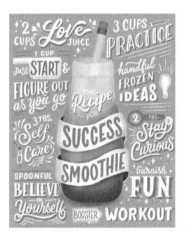

I started experimenting with different mediums for fun: lipsticks, chilli powder, and paper.

2020

I got more comfortable and used all the colors. Instead of trying to make my art appeal to everyone, I really embraced my pink and pastel palettes.

2021

Once I'd gotten comfortable with following the rules, I started letting my creative side run free and broke some rules to have fun. Now I don't follow the guidelines as much and embrace the wobbly look of the lettering more. No worries, I will show you how to break rules in chapter 6.

Will my style stay like this forever? I'm not sure. It might change based on my feelings or life experience. Nothing lasts forever. We just gotta embrace the journey, right?

KEY TAKEAWAYS

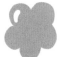

Knowing basic terms helps you hold meaningful conversations about letters with other artist friends instead of calling this or that "thingy."

Don't stress about memorizing all the terms right away; keep this chapter handy for reference.

Knowing the basic lettering styles is a good starting point before finding your artistic voice.

Instead of rushing to find *your style*, explore what kind of message you want to communicate to the world. Your personal style will evolve over time.

CHAPTER 3

What is the typographic eye?

The optical illusions of typography

How to train your typographic eyes

WHAT IS THE TYPOGRAPHIC EYE? WHY DO YOU NEED IT?

You know how they always say "Trust your gut"? If you're a lettering artist, you also need to trust your typographic eye. It takes time and practice to build trust. The more you exercise your eyes, the sharper they will be.

Chefs, to improve their palate, need to train their tongues to recognize flavors and deduce a recipe's ingredients. Musicians, to improve their hearing skills, have to train their ears to identify pitches, chords, and other elements of music. In the same way, letterers and designers train their typographic eyes to judge the readability, balance, and weight of a piece.

THE OPTICAL ILLUSIONS OF TYPOGRAPHY

There are three main shapes that the letters in the Roman alphabet are based on: the square (one example is *H*), the circle (*O* or *C*), and the triangle (*A* or *V*).

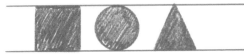

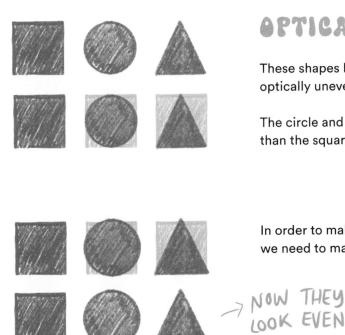

OPTICAL ADJUSTMENT

These shapes have the same height but are optically uneven.

The circle and triangle have less surface area than the square.

In order to make the shapes look optically even, we need to make the circle and triangle bigger.

→ NOW THEY LOOK EVEN

Following the same principle, rounded letters like *C* and *O* look shorter than squarish letters like *H* and *T* at the same height, because less of the character touches the baseline. In order to make the letters look optically correct, we overshoot, which means having the letters hang slightly below the baseline and rise slightly above the x-height.

OVERSHOOT

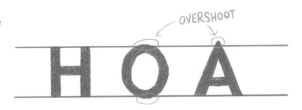

OPTICAL SPACING

Based on a ruler, this is the "right" spacing between the shapes.

But as you can see, different shapes create unequal negative spaces.

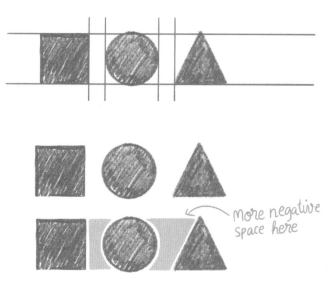

more negative space here

To make it look even to the eye, adjust the spacing between the shapes.

Now the spacing looks even optically, although if you looked at it again with guidelines and measured with a ruler, the spacing would not be even.

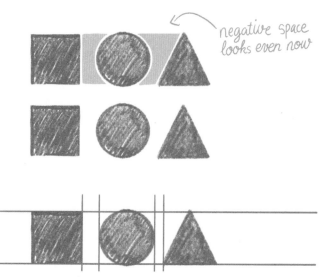

negative space looks even now

SPACE

SPACE

Let's look at this spacing example. This is even spacing between the letters using a ruler. Because of the letter's shapes, the spacing between *P* and *A* appears wider than the rest of the letters.

SPACE

SPACE

It looks more optically even if you move *A* closer to *P*.

At the end of the day, the purpose of lettering is to deliver a message that is pleasing to the eye. So trust your eyes first, then your ruler.

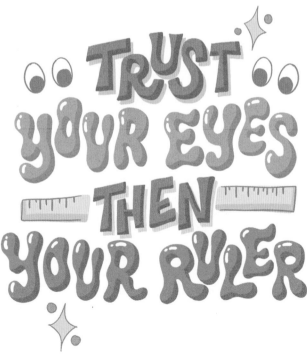

TRUST YOUR EYES THEN YOUR RULER

HOW TO TRAIN YOUR TYPOGRAPHIC EYE

Having a good typographic eye comes naturally to some people, but the good news is that anyone can train it by exercising their vision. The best way to learn lettering is to inspect and imitate existing pieces. That will be helpful when creating your own later.

PAY ATTENTION TO YOUR SURROUNDINGS:

- I noted in the previous chapter that typography is all around you if you train yourself to see it: packaging (cereal boxes, sauce bottles, milk cartons), book covers, street signage, apparel, and so much more.

- Analyze each lettering piece by looking at it as a whole. What is your initial impression? How does it make you feel? Then deconstruct the piece by looking at the details: colors, lettering styles, composition.

COLLECT YOUR OWN LETTERING LIBRARY:

- It's your turn to create your own lettering collection and make notes about what you like about each piece. Take a walk, look around, and take photos of any signage that looks cool to you.

- Next time you're in a grocery store or at a restaurant, pay attention to the packaging and the menus. Especially at stationery stores—I totally nerd out all the time while looking at all the awesome products.

HERE IS MY COLLECTION:

1 Storefront in Mexico City, Mexico
2 Painted signage in Hanoi, Vietnam
3 Vinyl CD cover
4 Vintage tin can packaging
5 Book cover
6 Vinyl CD cover
7 Signage in Tulum, Mexico
8 & 9 Storefronts in Los Angeles

You can strengthen your typographic eye by analyzing and breaking down a lettering piece you see.

EXAMPLE I

Let's look at this storefront in Vietnam.

The dot of the i is replaced with the star, which is the same symbol as on Vietnam's flag.

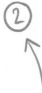

T *is lettered in two ways.*

H, u, *and* n *share similar shoulder strokes.*

The long bar balances the composition.

A swash is used to extend h. *It's a nice touch to end the word.*

EXAMPLE 2

When I look at this record cover's design, this is my thought process.

This script lettering style of Captain & Tennille really caught my eye. It's elegant but bold at the same time.

The swashes of the letters C, p, T, and e help with the nice movement throughout the piece.

⑥ *The capital C extends to hold the p.*

SONG OF JOY

⑤ *Ligature is formed between p and t.*

③ *The ampersand fits nicely in the uppercase T.*

② *The disconnected e stroke makes it unique.*

① *The white 3D part with the light-blue gradient makes the script pop even more against the light-yellow background. It definitely gives you the feeling of "Song of Joy" like the album's title.*

IDENTIFY SIMILAR TRAITS BETWEEN FONTS:

Typefaces are just like humans; that's why there are font families where all the letters are like siblings and share similar DNA traits. By identifying one trait of a letter, you will be able to draw the other letters.

If you're not familiar with all the terminology that goes with these genetic traits, that's totally fine. Keep chapter 2 handy.

**TIMES NEW ROMAN
FONT FAMILY**
(lowercase)

a b c d e f g
h i j k l m n
o p q r s t u
v w x y z

SAME BOWL

b d p

SAME SHOULDER

h m n u

(uppercase)

A B C D E F G
H I J K L M N
O P Q R S T U
V W X Y Z

These letters share DNA traits:

SAME ROUND STROKE

C D G O Q

F E

E & F are almost the same, except this stroke

SAME VERTICAL STROKE

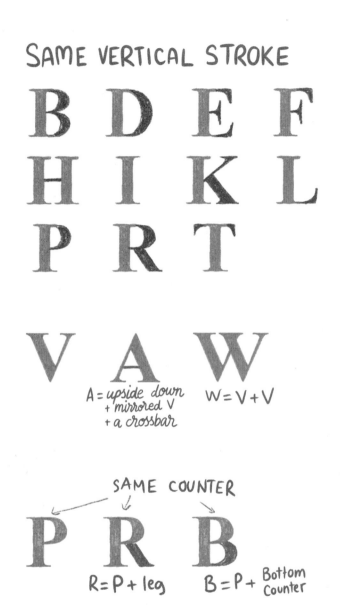

B D E F
H I K L
P R T

V A W

A = upside down
+ mirrored V
+ a crossbar

W = V + V

SAME COUNTER

P R B

R = P + leg B = P + Bottom Counter

R K These two are distant cousins.
They share their vertical stroke
and similar legs.

Let's use these principles to identify other letters based on the letters on this vinyl cover.

n → m h
u → i
e → c
B → P → R
u + g → y
g + u → a → d → b

KEY TAKEAWAYS

Letterers and designers train their typographic eyes to judge the readability, balance, and weight of a piece.

Trust your eyes first, then your ruler.

All the letters in a font family are like siblings and share similar DNA. If you can identify one trait of a letter, you will be able to draw the other letters.

WHAT
C
A LETT
TOOL

4

Before you run to the art store to buy all the tools listed below, hold up and read this first.

I used to think that I needed the best tools and the perfect moment to start lettering. I had this whole set of expensive pencils of different sizes, fancy sketchbooks, and the best brush pens (sworn by on the internet, because Google knows everything). Guess what? I made the best lettering pieces with those tools. JK, I was too scared to use them because my sucky art was not worth their value. So those pretty perfect tools just sat in my drawers for years, and I ended up giving them away.

I waited two years, and that "perfect" moment to create never came. I decided to just draw. With a Sharpie and a random piece of paper, I drew my first lettering piece. May I proudly present to you my first ever lettering piece, from 2014.

It might not look too impressive to you, but I was so proud of it.

The bottom line is you don't need fancy tools to learn and practice lettering. Just simple paper and a pencil will do. Hey, even a piece of toilet paper or a paper napkin can work too. (We all know how valuable toilet paper is after the COVID-19 pandemic.)

Save money, create better!

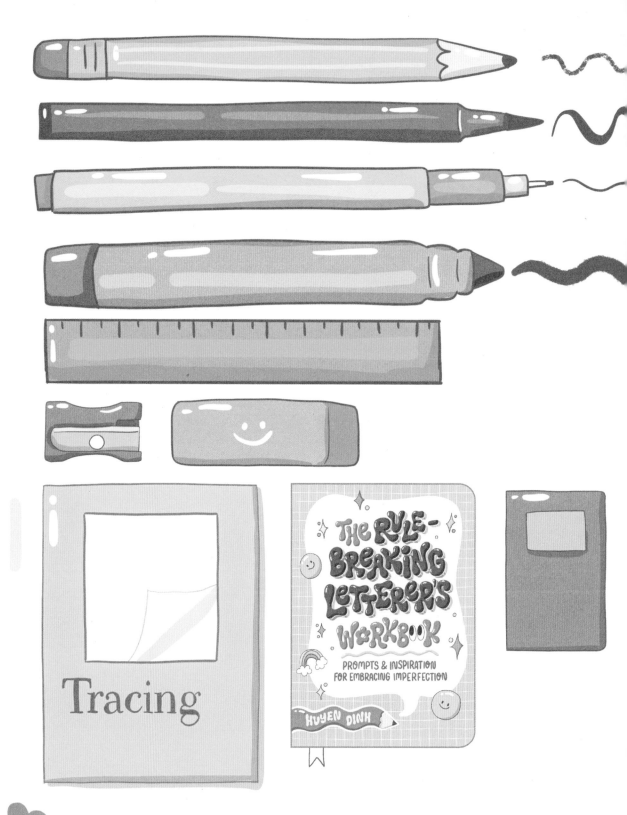

ANALOG TOOLS

SKETCHBOOK

If you have blank-page anxiety and need some "pick-me-ups" throughout your creative journey, I designed that kind of sketchbook just for you to use. Check out *The Rule-Breaking Letterer's Workbook*.

For blank sketchbooks, my favorite brand is Baronfig.

You can go with either hardcover or softcover. I tend to carry my sketchbook around, so I prefer hardcover to keep it in good shape.

TRACING PAPER

This is useful for experimenting with different lettering styles. You can lay the tracing paper on top of your sketch and draw without having to erase anything.

SMALL NOTEBOOK

Ideas come at unexpected moments, and it's important to write them down right away before you forget. Keep this mini notebook in your bag, near your bed, anywhere it's easy to grab.

If you prefer digital, any notes app on your phone will work.

PENCIL

The good old #2 will work just fine. If you don't like to sharpen pencils, a mechanical model is another option.

ERASER

I like a kneaded eraser because it removes pigment from paper without leaving "crumbs."

BRUSH PEN

Although you might not need it for lettering, a brush pen is really helpful for learning to make thick and thin strokes, which will help with your overall lettering learning process. Tombow brush pens are affordable and easy to use.

INK PEN

My favorite brand is Sakura Pigma Micron Pen. These pens are great for inking and detailed work. Bonus point is the ink doesn't bleed through the paper.

MARKERS

It's always fun to use your lettering skills to add personalities to your stuff. My *Rule-Breaker's Markers* markers are waterproof and can be used on different surfaces.

The tools listed above are just suggestions. You absolutely don't need all of them.

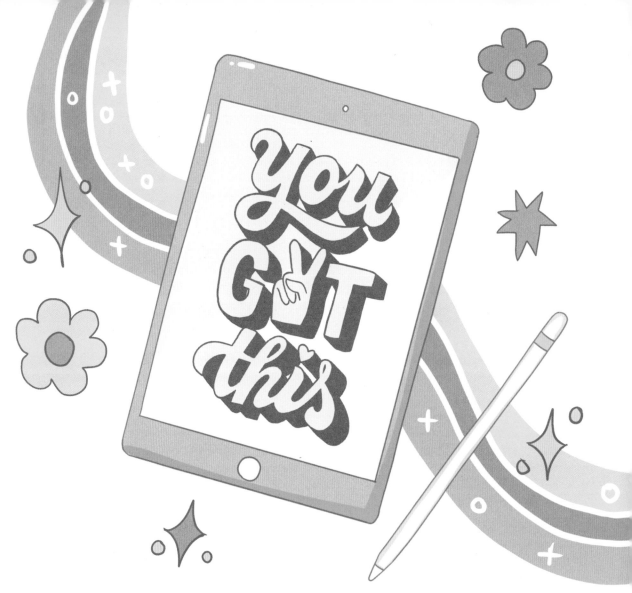

DIGITAL TOOLS

If analog is not for you, there are digital options such as Procreate, Photoshop, or Illustrator. I do everything (including all the art for this book) on my iPad and in Procreate. The information in this book works with both paper and digital. Find out which creative process works best for you.

The most important tool is your courage to show up and learn lettering.

4 KEY TAKEAWAYS

 You don't need fancy tools to learn and practice lettering. Just simple paper and pencil will do.

 Start with what you have.

THE CREATIVE PROCESS

5

CHAPTER 5

1 BRAINSTORMING

2 UGLY SKETCHES

3 DETAILED SKETCH

4 FINALIZING

SINCE YOU PICKED UP THIS BOOK, CHANCES ARE YOU ARE AN ANXIOUS ARTIST.

Oh hey, nothing's wrong with that. If your creative process looks like this, I feel you and I gotchu.

BEFORE

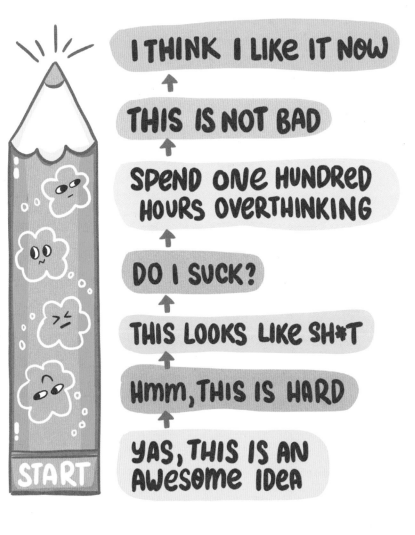

I THINK I LIKE IT NOW

↑

THIS IS NOT BAD

↑

SPEND ONE HUNDRED HOURS OVERTHINKING

↑

DO I SUCK?

↑

THIS LOOKS LIKE SH*T

↑

Hmm, THIS IS HARD

↑

YAS, THIS IS AN AWESOME IDEA

START

Based on my decade of creating and overthinking, I've broken the lettering process down into four steps, from start to finish, that might help you avoid getting headaches and cursing at yourself.

AFTER

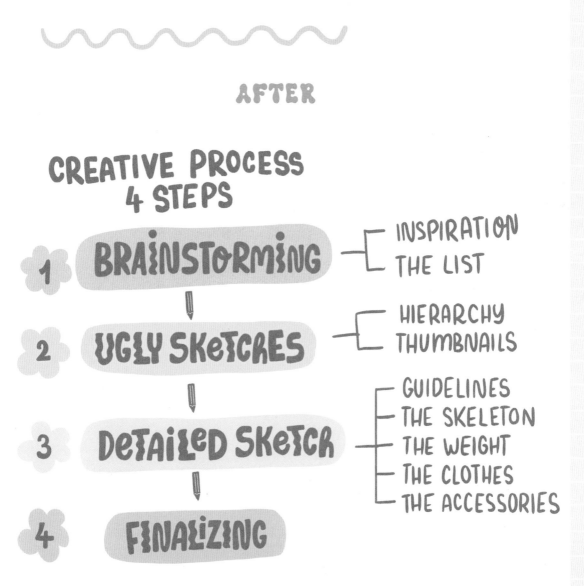

CREATIVE PROCESS
4 STEPS

1 BRAINSTORMING ⎯ INSPIRATION
 THE LIST

2 UGLY SKETCHES ⎯ HIERARCHY
 THUMBNAILS

3 DETAILED SKETCH ⎯ GUIDELINES
 THE SKELETON
 THE WEIGHT
 THE CLOTHES
 THE ACCESSORIES

4 FINALIZING

1 BRAINSTORMING

Are you ready to create a piece of lettering? Hold on! Before you draw anything, we gotta brainstorm.

"I don't know what to letter." This is one of the most common struggles that beginners usually face. Sure, it might be easier to grab an existing quote to letter; but at the end of the day, that's someone else's voice, not yours. Having your own messages to letter will make your art more personal and let people know who you are as an artist.

SO WHERE DOES INSPIRATION REALLY COME FROM?

Before you start scrolling like crazy on your phone, take a moment and notice your surroundings. The internet is not the only place to look for inspiration.

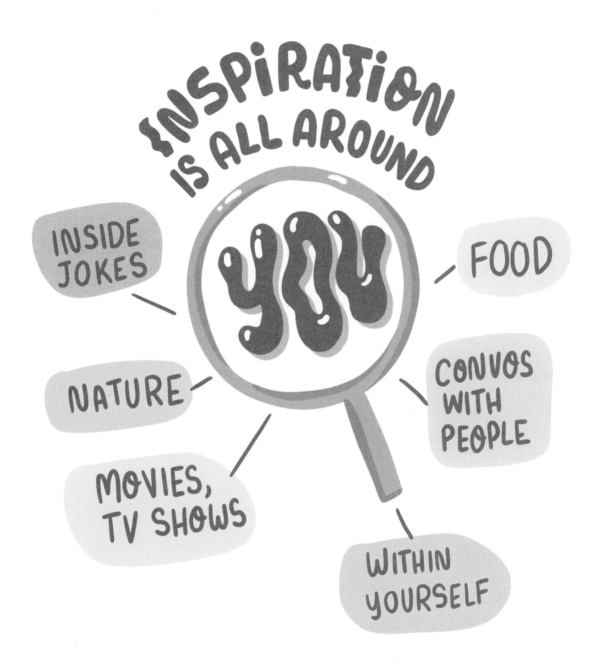

FIND INSPIRATION IN YOUR SURROUNDINGS:

Anything around you can become a message for your lettering piece: conversations with people, pets, inside jokes with your friends, movies, TV shows, and so much more.

Most of my ideas come from chatting and joking with my friends. One time a friend teased me about how I overthink everything (like literally everything). I told her that I'm a professional overthinker. If I can't completely change it, why not embrace it? So the light bulb went off and I created this after the conversation:

I even wrote my resume for this profession, hah:

RESUME

✦ **With more than thirty-one years of experience, I have excelled in over-thinking in many aspects of life:** daily routine, relationships, work, big stuff, little stuff, and so much more.

✦ **Attention to detail and high proficiency.** I think of any possibilities that exist.

✦ **Flexible:** able to handle multiple (well hundreds) of thoughts at the same time.

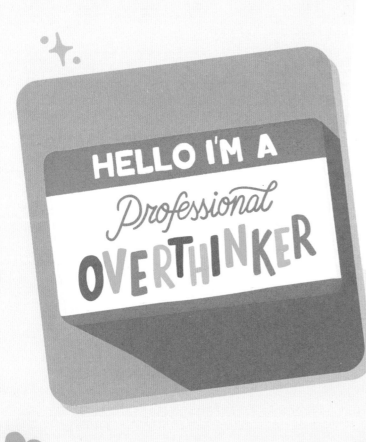

HELLO I'M A
Professional
OVERTHINKER

Do you think I'm qualified as an OVERTHINKER?

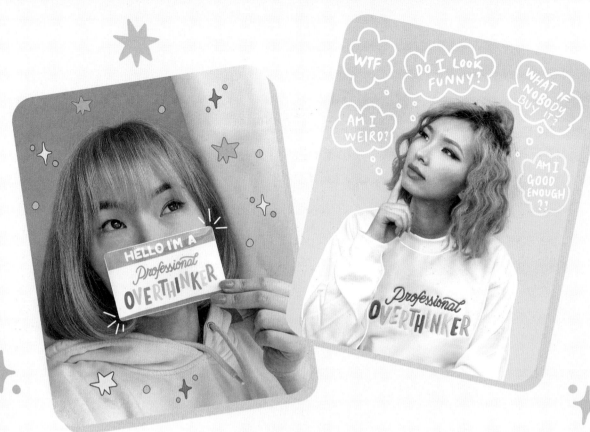

Turned out, there were so many overthinkers out there. Because people loved the piece so much, I turned this design into different products: caps, sweatshirts, tees, and stickers. I released the white version first. The first launch was a big success.

People kept asking for more, so I ended up doing it in four other color variations.

What started as a silly idea became a bestselling product that generates thousands of dollars for my online business. This design also brought me many opportunities to collaborate with well-known brands such as Trader Joe's, Facebook, LG, Canon, and many more.

You never know where your silly ideas will take you, so don't be afraid to make them happen. Inspiration is all around you; you just need to keep your eyes (well, and your ears in some cases) open.

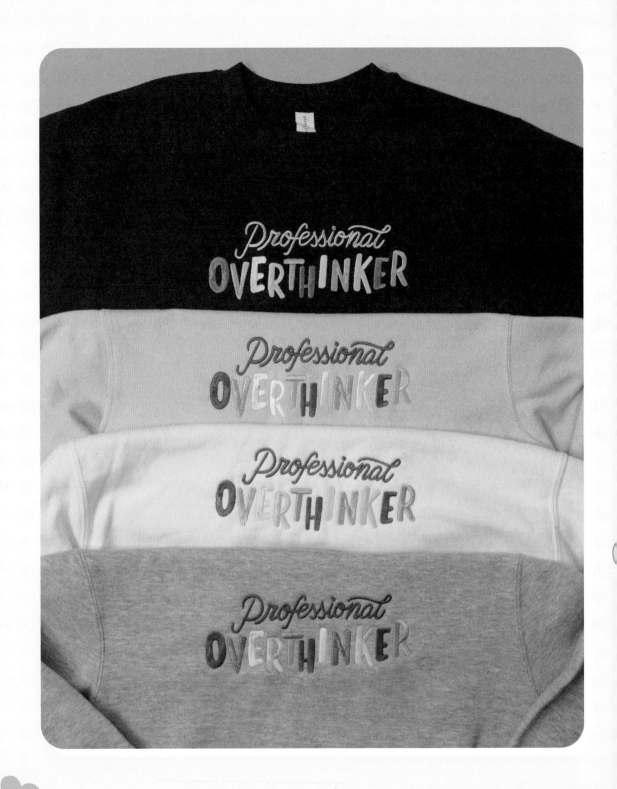

FIND INSPIRATION WITHIN YOURSELF:

One place that people often overlook when searching for inspiration is within themselves. Yes, YOU! You have so much potential that you don't know about. Journaling and staying true to my feelings have helped me so much with coming up with ideas. Whenever you come across a situation that makes you feel something, put it down in your notes for future use.

Here is a screenshot of my random notes; they might not make sense to you, but they're totally helpful when I'm coming up with ideas.

< Notes

March 2, 2022 at 2:32 PM

Brain Dump

○ Size does matter.

○ Success is not about the finish line. It is about how you evolve during the journey.

○ Moving on is not forget
But carry the pain with u

○ Things I learn after a heartbreak:
Love is not enough
There will not be closure

○ Everything is temporary: feelings, thoughts, people, and moments.

○ Don't worry about the bad things that might happen, because like clouds passing by, they won't last forever."
Like clouds passing by, bad things might happen but don't worry because it won't last forever.

○ better days are coming

○ It's ok to not fit in. you are your own category

○ FOCUS is my 2nd favorite F word. Food it the first obviously

When it comes to feelings, it's OK to not be happy all the time (oh hey, this sentence could totally be a lettering piece). You can letter based on your emotions.

Once you feel inspired, start a brainstorm list of words, phrases, and other elements related to your subject.

For example, this is my brainstorming process for a coffee mural project. The client wanted coffee pun murals for their interactive museum to offer laughter and awesome photo ops for their visitors. Here are my scribbled lists; remember, this doesn't need to be organized or fancy:

COFFEE PUN PHRASES:

YOU'VE BEAN ON MY MIND
WE'RE THE PERFECT BLEND
COFFEE IS MY LOVE LANGUAGE
IT'S COFFEE O'CLOCK
I LIKE BIG CUP & I CANNOT LIE

COFFEE ICONS:

BEANS
COFFEE CUP
LATTE ART
MILK CARTON
PAPER CUP
SPOON
FRENCH PRESS
CREAMER
WHIP CREAM
FRAPPE

The coffee icon list will be useful for adding illustrations in step 3: the detailed sketch.

HERE ARE SOME TIPS FOR YA TO GET BETTER AT BRAINSTORMING:

 Nothing is silly when it comes to brainstorming (Did you see my Pooticorn on the other page?).

 Start your "Ideas Bank" by always carrying a pocket-sized sketchbook with you. Leave one near your bed. Sticky notes or your phone work as well—whatever item you can reach the fastest when your ideas come.

There is no best time to brainstorm, just what works for you. My brainstorming process doesn't really have a schedule. My ideas like to pop up out of nowhere, and I have to catch them right away (a.k.a. write them down) before they disappear. Once your Ideas Bank is rich with savings, you won't run into the situation of having no ideas to work on.

 Never go with the first idea that comes to mind (I know Justin Bieber said never say never, but trust me on this one). Your first idea might be the most convenient, but it might not be the best one. Don't settle for less. Keep pushing before jumping into execution mode.

Memes are the best place for inspiration. They're short, punny, and relatable. Who doesn't want a good laugh?

Pick a popular quote and swap one word out. For example:

"Just **do** it" (Nike's famous trademark) becomes "Just **draw** it" (with a pencil illustration).

"Ho Ho **Ho**" becomes "Ho Ho **Home** for the Holidays" since we all stayed home during the COVID-19 pandemic.

You don't have to do it alone. Two is better than one: Bounce ideas off your friends who have the same interests. (Don't just ask random people, they might discourage you.)

2 UGLY SKETCHES

Ugly sketches are a must-have in the creative process. Let me repeat it again: THEY'RE A MUST-HAVE. Most people are ashamed of their sketches because they look "ugly." But that's why they are called *sketches*. Duhhh, they don't need to look polished. We should embrace our ugly sketches. They have their charm, ya know.

Sketching thumbnails is similar to doing a warm-up before working out. It will prepare your creative muscles for a better creative flow.

WHAT'S THE POINT OF UGLY SKETCHES (A.K.A. THUMBNAIL SKETCHES)?

✦. They're a quick way to get your creative juices flowing.

✦. They help with composition choices, which will save you time on your final piece.

✦. They help eliminate what you don't like.

HOW TO THUMBNAIL:

✦ Determine the hierarchy within your phrase. The hierarchy will help the composition flow better and put emphasis on important words of your phrase.

First, write your phrase out.

Second, underline each word and assign each a number based on how important it is to the meaning of the phrase:

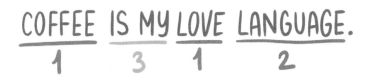

1 - the most important (mostly verbs, nouns, or adjectives)

2 - secondary importance

3 - the least important (like articles, conjunctions, and prepositions: and, or, if, etc.)

This will help you know where to put visual emphasis in the composition, using color, weight, and size.

Sometimes when you emphasize the wrong words, your piece might deliver the wrong message to your viewers.

QUICK NOTES

- It's OK to be messy at this point.

- Sketch fast and don't worry about details. Look at the big picture instead.

- Explore different compositions and combinations of styles.

✦ Draw small thumbnails (two to three inches wide) that have the same proportions as your final design. Play around with the guidelines and arrangement (more details about this in chapter 6).

LET'S DRAW SOME UGLY SKETCHES FOR THE PHRASE: "COFFEE IS MY LOVE LANGUAGE."

Using the same style for words with the same importance helps with the flow of your message. In this case, *coffee* and *love* will have similar styles. *Is, my*, and *language* will have other styles that contrast with the main words.

My thought process while sketching:

There is no "right" number of thumbnails you have to do; do as many as you want. I usually start out with two to three ugly sketches and choose one to refine.

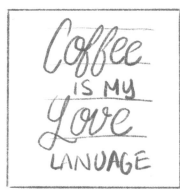

Ugly sketch 1
A straight baseline is the most basic composition to start with.

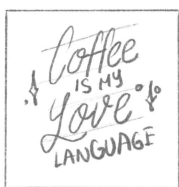

Ugly sketch 2
Then maybe I should make the main words diagonal.

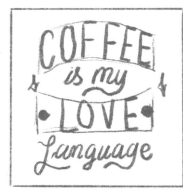

Ugly sketch 3
How's about fitting the words in an arch shape?

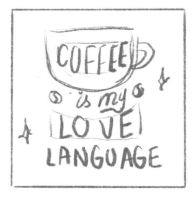

Ugly sketch 4
Whoo, I'm having fun with these ugly sketches! Let's try fitting the type inside a coffee cup shape.

🌸 3 DETAILED SKETCH

Like we talked about before in chapter 2, typography is really close to the human body. The sketching process can be thought of in a similar way:

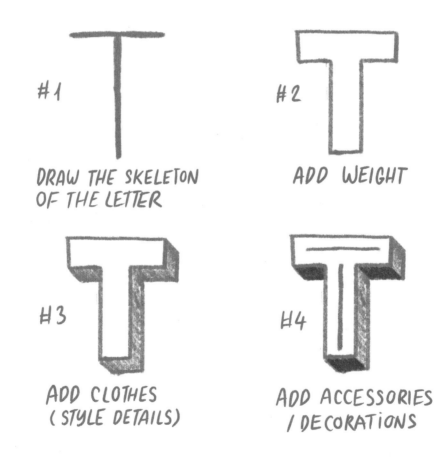

#1 DRAW THE SKELETON OF THE LETTER

#2 ADD WEIGHT

#3 ADD CLOTHES (STYLE DETAILS)

#4 ADD ACCESSORIES / DECORATIONS

I'M PERFECTLY IMPERFECT

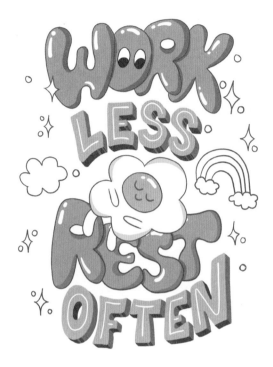

WORK LESS REST OFTEN

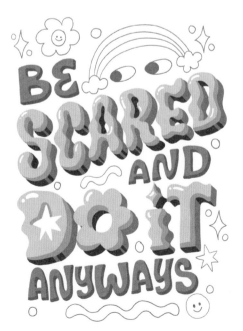

BE SCARED AND DO IT ANYWAYS

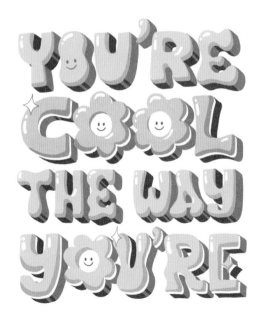

YOU'RE COOL THE WAY YOU'RE

THE GUIDELINES:

Refer to the guideline section in chapter 2 to set up your baselines, x-heights, and cap heights. If you have italic lettering, diagonal lines will help all the letters stay on the same angle consistently.

Have your chosen thumbnail sketch handy to help with setting up the guidelines. You can use a ruler for straight lines, but most of my compositions are pretty loose so I usually freehand this.

I chose the first thumbnail because it is simpler, and I can add illustrations around it without making the whole composition too busy. Here are the guidelines I created with this sketch in mind.

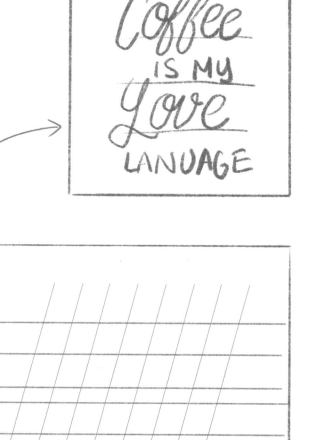

THE SKELETON:

Draw the skeleton of the phrase using hairline strokes. Focus on the structure and proportion at this point and not small details (since we usually add accessories last when we dress up). Having a good skeleton is like having a blueprint when you build a house. You can't build up if you don't have a good base.

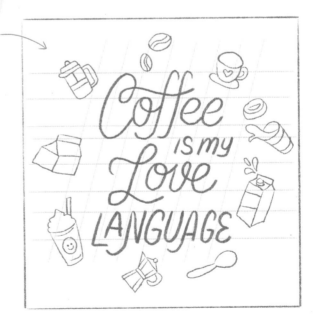

TO FILL THE SPACE, ADD ICONS USING THE BRAINSTORMING LIST IN STEP 1

THE BODYWEIGHT:

If you're pleased with the skeleton, time to add some bodyweight. All sizes are welcome.

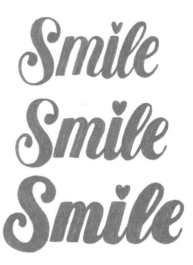

Monoline weight
Same line weight throughout the words; there is no contrast between strokes.

Low-contrast letters
The difference between thick and thin strokes is minimal.

High-contrast letters
The difference between thick and thin strokes is noticeable.

You can try thickening the serif part to create interesting visuals.

Play with different weights to see what you like. There is no formula to this.

FRESH

FRESH ← Weight can be add to the serif part

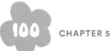

LET'S ADD WEIGHT TO THE SKELETON OF "COFFEE IS MY LOVE LANGUAGE."

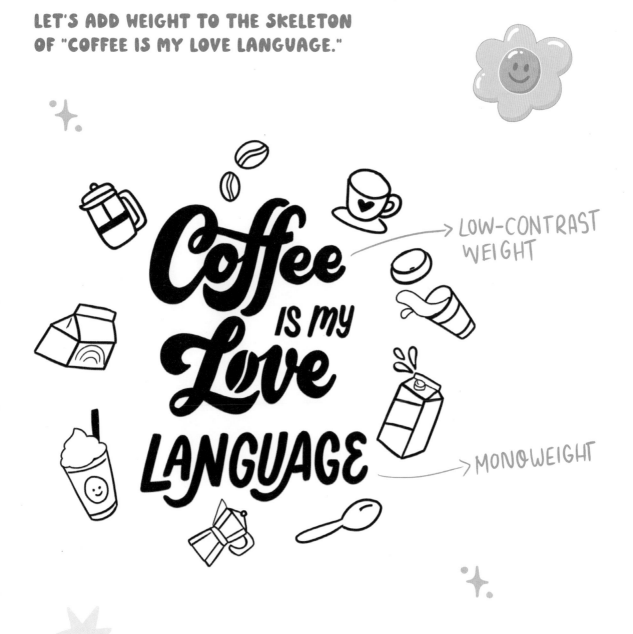

> LOW-CONTRAST WEIGHT

> MONOWEIGHT

THE CLOTHES:

It's time to try on different outfits for your lettering, a.k.a. adding dimension.

There are three variations of adding dimension: drop shadow, drop shade, and drop line.

The question is, how do you know where to place the drop shadow? Your imagined light source will come to the rescue. I like to draw a little sun as my guide. The shadow will be on the opposite side of where the light hits your letter.

← NOT CONNECTED

DROP SHADOW

← CONNECTED

DROP SHADE

DROP LINE

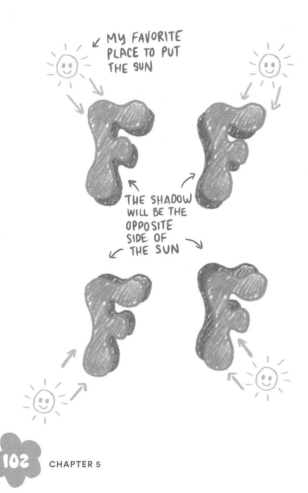

← MY FAVORITE PLACE TO PUT THE SUN

THE SHADOW WILL BE THE OPPOSITE SIDE OF THE SUN

My favorite place to put the sun is in the upper left of the letter. Then the shadow will be at the bottom right of the letter.

MAKE IT AS THICK AS YOU WANT

"COFFEE IS MY LOVE LANGUAGE"
AFTER ADDING CLOTHES.
(in this case a drop shade)

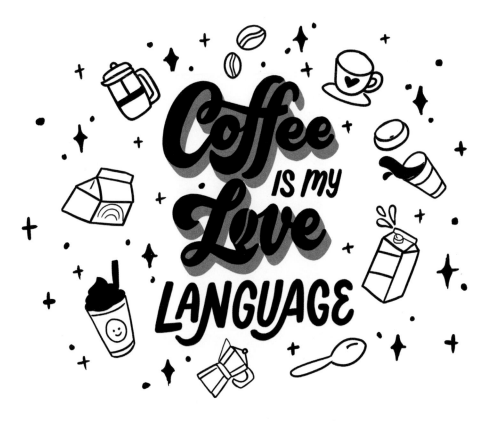

THE ACCESSORIES:

This is the extra-fun part: when you can complete the look of your lettering by adding accessories (decorations). You can go all out here. There is no set rule when it comes to being extra. Just make sure the lettering is still legible at the end.

Here are different ways to draw and decorate the letter *a*. The possibilities are endless.

You can also use swashes, which I will explain more in chapter 6.

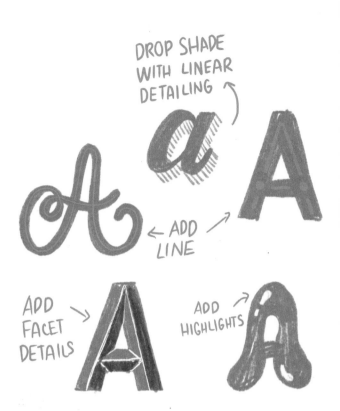

Adding decorative elements (sparkles, dots, stars, lines, and splashes) can help fill the empty space of the composition.

Think of adding decorations in layers.

LAYERS OF
DECORATIONS

→ BASE

→ ADD
DROP SHADE

→ DETAILS
ON
DROP SHADE

→ OUTLINE

→ LINE
DETAIL

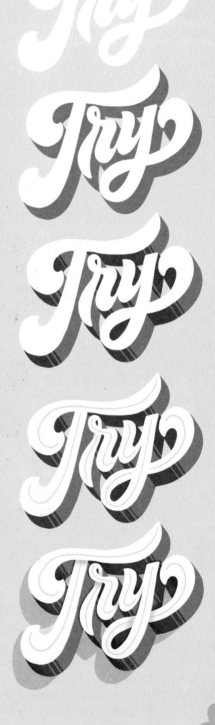

FINAL SKETCH OF "COFFEE IS MY LOVE LANGUAGE."

I added lines on the main lettering and line details on the drop shade to highlight the shading. Last but not least, I included a lot of sparkles in the background—because why not and they also help fill empty space.

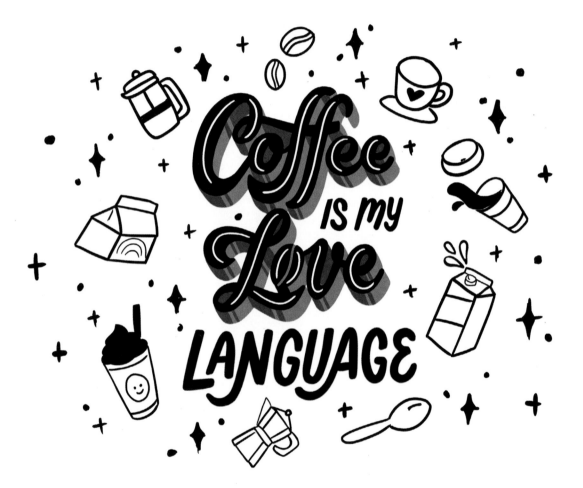

QUICK NOTES

- *Don't sketch too small, leaving no room to explore details.*

- *Fill in the letters when you sketch instead of outlining so you can see the contrast better.*

- *Squint your eyes to see if everything looks balanced.*

- *Legibility is everything since lettering communicates a message to your audience.*

- *Don't sweat over sketching pretty in one smooth stroke. My lettering is always made of millions of tiny strokes. As long as we get to the final result, right?*

4 FINALIZING

Almost done, guys!

You can use your favorite analog methods (pen and paper) or digital programs (Photoshop, Illustrator, Procreate, Adobe Fresco) to finish your lettering. Ready to apply this process to your own piece?

Here is my final coffee piece—digital version using Procreate:

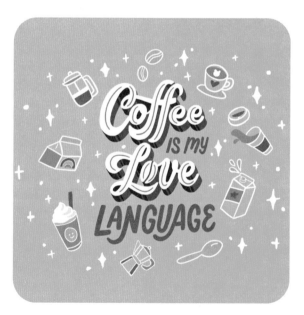

And here is the mural
I painted, ta-da!

STEP 1: BRAINSTORMING

COFFEE PUN PHRASES:

YOU'VE BEAN ON MY MIND
WE'RE THE PERFECT BLEND
COFFEE IS MY LOVE LANGUAGE
IT'S COFFEE O'CLOCK
I LIKE BIG CUP & I CANNOT LIE

COFFEE ICONS:

BEANS
COFFEE CUP
LATTE ART
MILK CARTON
PAPER CUP
SPOON
FRENCH PRESS
CREAMER
WHIP CREAM
FRAPPE

STEP 2: UGLY SKETCHES

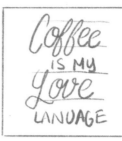
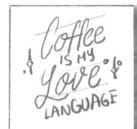
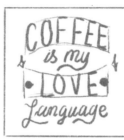
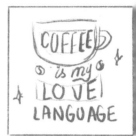

STEP 3: DETAILED SKETCH cont

The bodyweight

The clothes

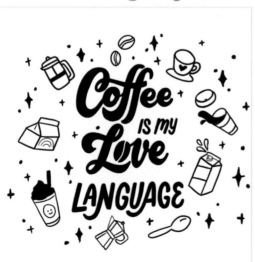

STEP 3: DETAILED SKETCH

the guidelines

The skeleton

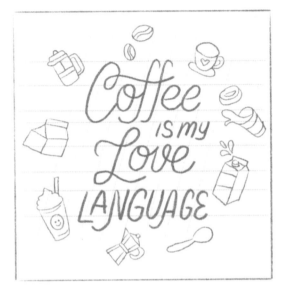

STEP 4: FINALIZING

the accessories

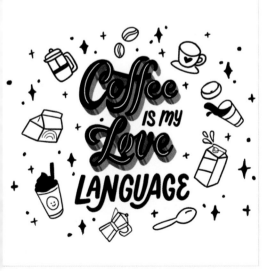

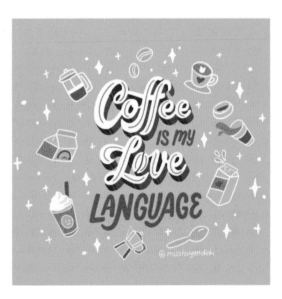

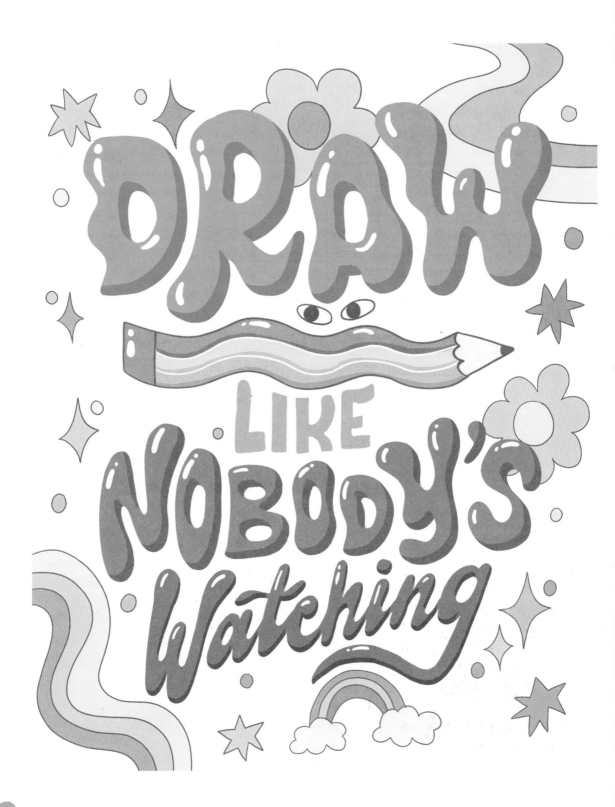

KEY TAKEAWAYS

The messy creative process can be organized into four steps: brainstorming, ugly sketches, detailed sketch, and finalizing your art.

Inspiration is all around you, even in the inside jokes with your friends. Don't be afraid to make your silly ideas happen.

It's OK to be messy while sketching. Embrace your ugly sketches.

Legibility is everything.

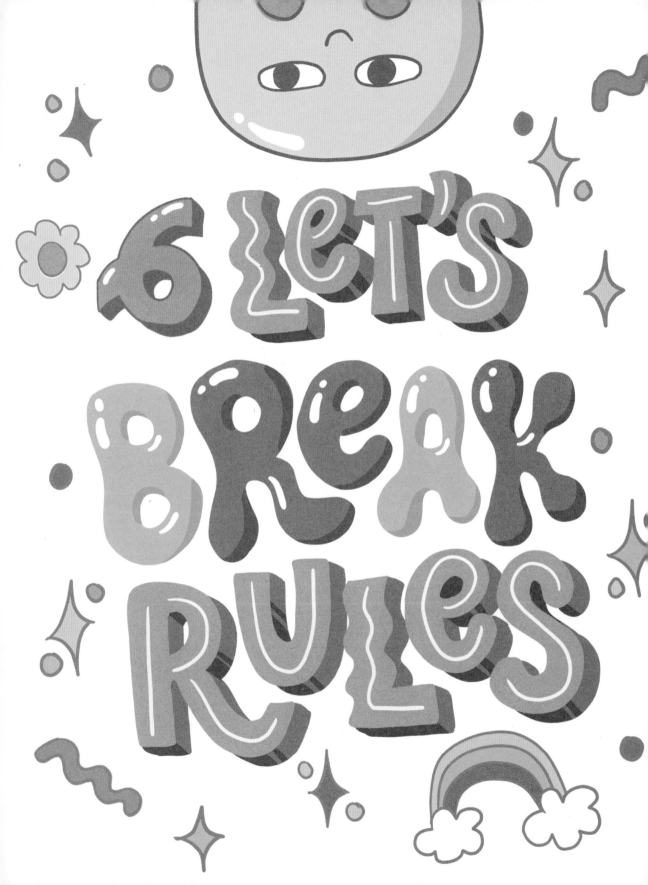

CHAPTER 6

1. Embrace perfectly imperfect strokes
2. Bouncy lettering
3. Reverse that rule
4. I like to move it, move it
5. Number of styles
6. Number of colors
7. The power of swashes
8. Stay in shape
9. Make your own rule

Now that you have a pretty good foundation in lettering, let the fun part begin: becoming a rule-breaking letterer! I know you've been waiting to get to this part.

Rules are there to guide us, but not to rule us. I'm not talking about breaking all the rules randomly: I break them with a purpose.

"One rule at a time" is the key. Pick a rule and focus on how you can break or bend it.

ONE RULE AT A TIME

(THEN YOU CAN FORGET THIS LATER)

EMBRACE PERFECTLY IMPERFECT STROKES

BASIC RULE:

Consistent line weight makes great lettering.

YES

USE THE SAME SKELETON, THERE'RE SO MANY WAYS TO DRAW WOBBLY STROKES.

LET'S BREAK THE RULE:

Inconsistent/wobbly line weight makes fun lettering. Embrace that imperfection; it has charm, right?

2 BOUNCY LETTERING

BASIC RULE:

The letters stay within the baseline.

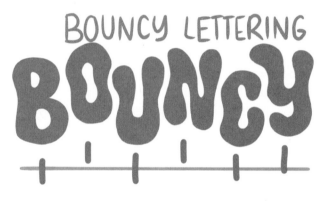

REGULAR LETTERING

BOUNCY

BOUNCY LETTERING

BOUNCY

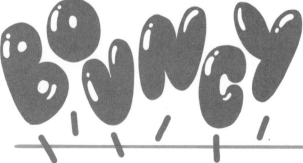

BOUNCY LETTERING
(the letters are also tilted)

BOUNCY

LET'S BREAK THE RULE:

The letters don't sit on the baseline.

It looks like they're dancing on the baseline. Some letters go above or below the baseline to give it that bouncy effect.

There're so many variations of making letters bouncy, but the way you draw will be the one and only. Isn't it awesome?

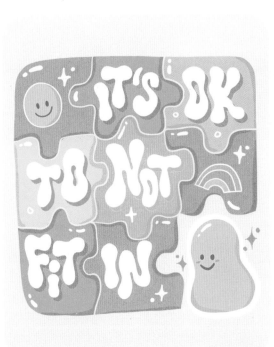

BASIC RULE:

THIN up, THICK down.

This rule mimics calligraphy style. When you use a brush pen, you apply light pressure on upstrokes and heavy pressure on downstrokes.

Upstrokes

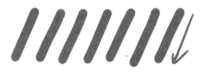

Downstrokes

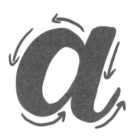

Combination

THICK up, THIN down.

By reversing the rule, you can create an interesting visual. In this case, upstrokes are heavy and downstrokes are thin.

Upstrokes

Combination

Downstrokes

the reverse rule can apply to sans serif

Down thick stroke
⇓
Up thick stroke

I LIKE TO MOVE IT, MOVE IT

BASIC RULE:

Letter the word using the standard guidelines.

LET'S BREAK THE RULE:

Play with the proportions and change the x-height to see what styles you can come up with. This will give your lettering different personalities.

] x-height

MAKE X-HEIGHT TALLER

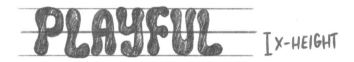] x-height

MAKE X-HEIGHT SHORTER

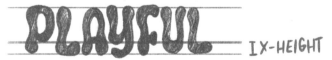] x-height

5

NUMBER OF STYLES

BASIC RULE:

Don't use more than three styles in a piece.

This rule is good when you're new to lettering. It's best to stick to fewer styles (up to three) so you're not overwhelmed by all the choices.

A helpful tip when choosing styles: opposites attract. If your main words are script, go with sans serif for less important words.

Example of using one lettering style: Serif

Example of using two lettering styles: Script + Sans Serif

Example of using two lettering styles: Serif + Sans Serif

LET'S BREAK THE RULE

(well, more like bending the rule in this case):

You can still stick to the no-more-than-three-styles rule, but with a twist. For each of the main styles in the piece, you can use different variations of that style to make it more playful. This is helpful for long quotes, lists, recipes, etc. Have fun with this as long as the words stay legible.

For example:

THIS PIECE SEEMS TO HAVE 14 STYLES AT FIRST GLANCE.

HOW MANY STYLES DO YOU SEE?

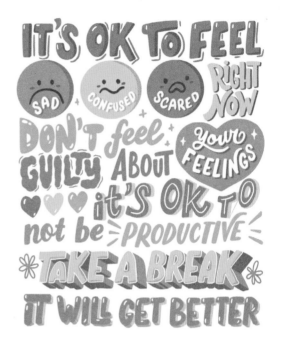

→ SANS SERIF 1

→ SCRIPT 1

SANS SERIF 2

SANS SERIF 3

SCRIPT 2

SANS SERIF 4

SANS SERIF 2

THERE'RE ONLY 2 STYLES: SANS SERIF AND SCRIPT WITH DIFFERENT VARIATIONS

HOW MANY STYLES DO YOU SEE IN THIS EXAMPLE?

Hint: I used three styles—serif, sans serif, and script—with different variations.

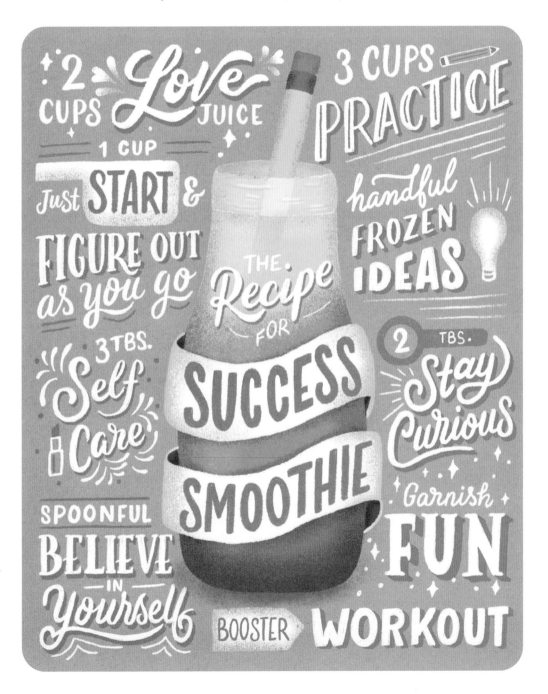

NUMBER OF COLORS

BASIC RULE:

Avoid using more than three colors in a piece.

A color scheme is a combination of colors used in an illustration. Different color schemes affect the mood of the piece in different ways. It might be helpful to think about how you want viewers to feel while looking at your lettering.

Energetic
(bold, vibrant colors)

Peaceful
(pastel colors)

Dramatic
(dark, high contrast colors)

How many colors can you use in your lettering piece? While there is no fixed answer, the rule of thumb is to start with a two- to three-color combination.

A color scheme with too many colors might look busy if not used properly.

1 color

2 colors

3 colors

LET'S BREAK THE RULE:

When in doubt, use all the colors.

A rainbow color scheme is fun and eye-catching.
There are so many possibilities for interpreting
a rainbow. It might be intimidating at first,
but have fun experimenting, and you'll find
the right balance for you.

HERE ARE SOME TIPS TO HELP YOU USE RAINBOW COLORS IN YOUR LETTERING:

 Pair rainbow lettering with neutral-colored backgrounds: black, white, beige. These colors will help balance or bring contrast to the vibrancy of the rainbow.

 You don't need to use all the colors in the rainbow. Since a rainbow is a well-known symbol, it's easy to recognize it even when you use only three or four colors from the spectrum.

You can blend the rainbow colors to create a beautiful gradient.

THERE'S NO SUCH THING AS TOO LATE YOU'RE HERE AT THE RIGHT TIME

BE SCARED AND DO IT ANYWAYS

7 THE POWER OF SWASHES

BASIC RULE:

Less is more.

LET'S BREAK THE RULE:

Embrace the extra with swashes.

WHAT ARE SWASHES?

Swashes are exaggerated parts of a letter. Depending on the composition, swashes are added to enhance the balance.

THE BENEFITS OF ADDING SWASHES

✦. They add visual interest.

✦ They help with the flow.

✦. They balance the composition by filling in gaps or negative space.

LETTER WITHOUT SWASHES LETTER WITH SWASHES

L → L

there're different ways to add swashes

Y → Y Y Y

t → t

m → m

R → R

HOW TO ADD SWASHES

✦ Write out a word as you normally would. Leave out the ascenders or descenders so you can explore different swash options.

✦ Try out different options to see which one has the best balance.

Sunny

OPTION 1:

Sunny

unbalanced

OPTION 2:

Sunny

I add swashes to "S" and "y" to fill negative space

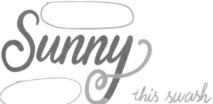

this swash still leaves a lot of negative space in the composition

TIPS:

The possibilities of adding swashes are endless, and it's good to experiment with different options to see which works better for the composition. But don't go too crazy: Overuse of swashes can be distracting.

Swashes should be complementary elements and shouldn't take the focus away from your main piece.

Adding swashes should be the final step of your composition. Just like when you're getting dressed, you don't put on accessories before you have your outfit.

Some easy letters to add swashes to are *t*, *y*, and *g*.

Sunhy *can you still read this?*

Uppercase letters are great to add swashes to

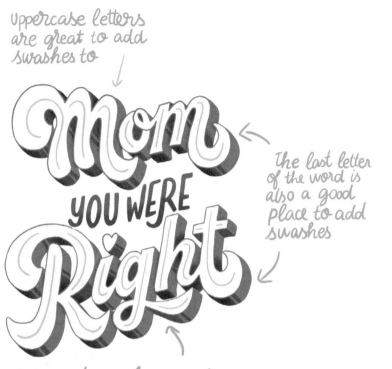

the last letter of the word is also a good place to add swashes

Descenders of "y" and g are easy to add swashes to

8 STAY IN SHAPE

Use guidelines for your lettering composition.

If the shape is simple and you can use the elements and letters to fill up the space, you can take out the outline

~@MISSHUYENDINH

LET'S BREAK THE RULE:

Instead of using the guidelines, you can fit the lettering into different shapes.

Here is how you can do it:

✦. Choose a shape that describes the word or phrase you're lettering.

✦. Roughly sketch out the layout.

✦. Play with each word to fill the shape.

✦. Don't distort the word too much. Make sure it is still readable.

Let's stay in shape. Donut give up!

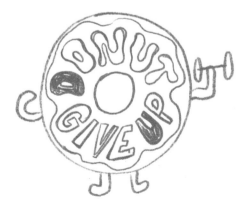

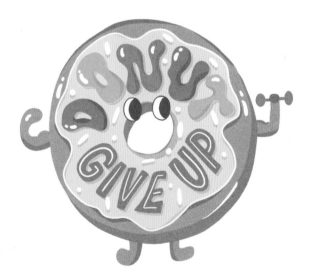

9 MAKE YOUR OWN RULES

BASIC RULE:

Follow the rules to be a good artist.

LET'S BREAK THE RULE:

Shhhh, don't tell anyone, but you know all my secrets for breaking the lettering rules. Now it's your turn to make your own rules.

There is no right or wrong here. You can make it happen.

BEING **U** IS YOUR SUPERPOWER

KEY TAKEAWAYS

Rules are there to guide us but not to rule us. By breaking or bending the rules with a purpose, you can create your unique style.

Some rules you can break:

1. Embrace wobbly strokes.

2. Let your letters bounce around the baseline.

3. Reverse the thick upstrokes and thin downstrokes rule.

4. Change the x-height.

5. Use different variations of lettering styles in your piece.

6. When in doubt, use all the colors.

7. Embrace the extra by using swashes.

8. Fit letters into different shapes.

Make your own rules: There is no right or wrong way, just your way.

 CHAPTER 7

MY STORIES

LETTER WHAT YOU FEEL, NOT WHAT PEOPLE WANT TO SEE.

By sharing your story and voice through lettering, you can make your art personal and unique.

THE STORIES BEHIND MY ART

By combining pastel color palettes and playful lettering and illustrations with a touch of quirky humor, I use my art to bring positive vibes and smiles to people's days.

THE FEELINGS STORY

When I first started my lettering journey, I used to letter cliché motivational quotes, but I felt really disconnected while drawing them. That's when I decided to dig deeper and letter about how I truly feel. Lettering is like writing in a journal for me, but with art.

As a sensitive soul, I sometimes felt silly for having all these feelings and thought I was the only one going through them. That's the worst feeling ever, and I don't want anyone else to experience it. I want my audience to know that they're not alone and that their feelings are valid. There is always someone out there who is going through the same thing.

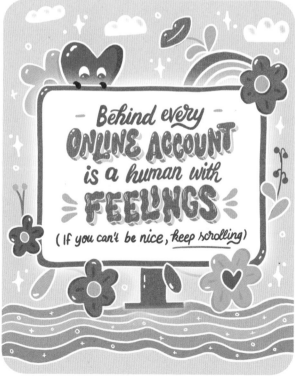

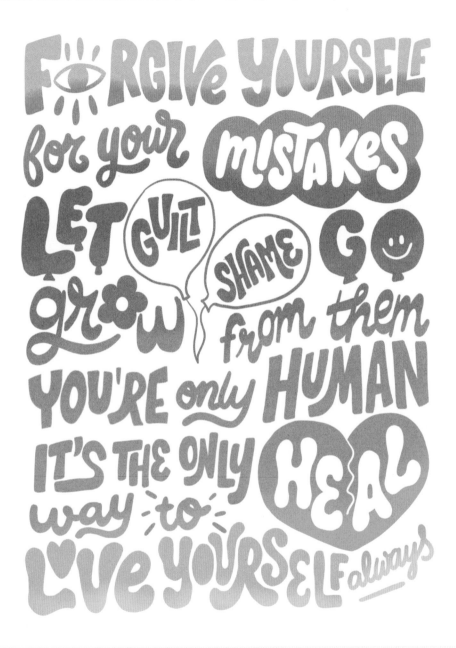

THE IMPERFECTION STORY

As an artist, I struggle with impostor syndrome a lot. Listening to your inner critic and comparing yourself to other artists can be very tiring. I thought to myself, if I can't change my imperfect strokes, why not embrace them? That wobbly edge has charm, you know!

I started showing my ugly sketches on my social media along with my final art, to encourage people to embrace their ugly sketches. There is no need to feel embarrassed and hide them. Because of those sketches, we're able to make the finals happen. Shouldn't we be thankful for them?

After I shared these, people told me that they made them feel better about their own sketches, and they actually started sharing them as well.

We often think other people's lives are perfect when looking at their highlight reels on social media. I found it very exhausting to try to achieve that unrealistic perfect life. So I decided to share my "normal" feelings (both the ups and downs) and the struggles that I face in my artistic journey. To my surprise, my vulnerability resonated with others deeply. I got many messages from people telling me that my art made their day and how they felt seen and connected with on a personal level. That's the best achievement I can ever ask for.

Even when writing this book, I acknowledged that it would not be the first lettering book on the market, but what makes it different is that I use my imperfect skill and normal experience to encourage you to embrace and find the strength in your own imperfections. A normal girl like me still has interesting normal stories to tell, and so do you.

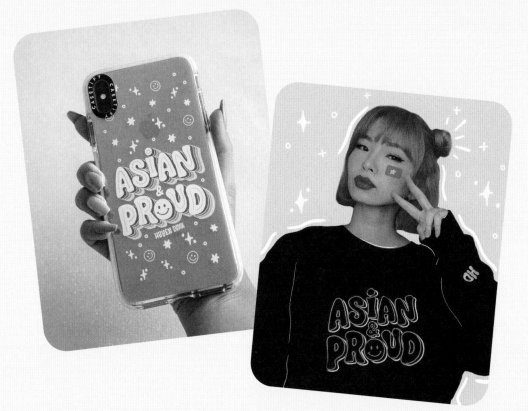

THE ASIAN STORY

I grew up in Vietnam, and having a multicultural back-ground gives me a different perspective and shapes me as an artist today. I want people to know that I'm a proud Viet artist so other Asians, especially Viet artists, can relate and tell their stories as well.

Through my lens, I saw myself as just a normal girl growing up in an average family without much talent. I was shy, introverted, and had a funny Asian accent. But I discovered that others found it fascinating to learn about where I'm from and how I adapted to American culture through their lenses.

We see ourselves differently from how other people see us because we live our lives every day. It's like watching the same movie again and again. But for others, it is their first time seeing the story, so it's new and interesting. What is "normal" to us can be beautiful to others.

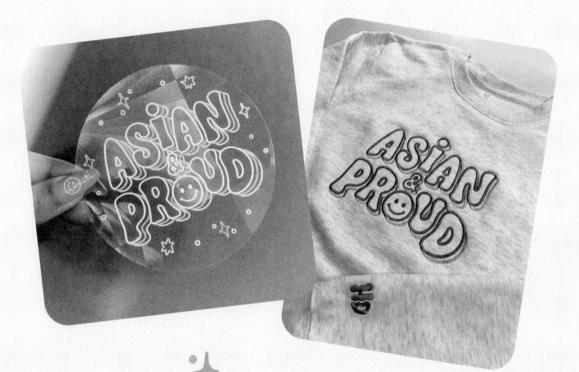

Everyone has a story worth sharing. You just need to give yourself permission to tell it.

YOU'RE NOT BEHIND YOU'RE JUST ON YOUR OWN PATH

HOW I TELL STORIES THROUGH MY ART

Most of my lettering pieces are pick-me-ups, so I use a lot of pastel colors because they bring a light, soft, and calm feel to my viewers.

I want to tell my stories through the lens of a female millennial who is finding her way through adulthood and along her career path. That's why you see a motif of cute emojis or characters throughout my work. Plus, I love adding facial expressions to illustrations for a quirky vibe.

To emphasize the uplifting feeling, I include a lot of sparkles and shiny lettering styles.

I love everything punny, so you can see my humor and a touch of my sassy personality through the quotes I choose. I also want to embrace the beauty of imperfection through my wobbly lines and strokes.

Each of my lettering pieces makes its own statement, but as a collection, they tell the story of my journey evolving as a person and as an artist. They remind people that you don't need to have everything all figured out at once. You just have to trust the process.

If you look at famous artists' work, there are always motifs in their use of icons, colors, or other elements you can instantly recognize. For example, Yayoi Kusama is known for her use of polka dots over and over again.

It's helpful to analyze other art pieces. What kind of story do you get from them? What elements support the story?

Panel 1:

Dear artists,

THERE IS NO SUCH THING AS AN ORIGINAL IDEA.

IT'S JUST THE MATTER OF HOW YOU ADD YOUR OWN FLAVOR TO MAKE IT YOURS.

DON'T TRY TO BE ORIGINAL, BE DIFFERENT.

KEEP CREATING, MY FRIENDS!

@MISSHUYENDINH

Panel 2:

Dear artists,

STOP LOOKING FOR THAT ONE STYLE.

FOCUS ON YOUR ARTISTIC VOICE.

WHAT KIND OF MESSAGE U WANT TO COMMUNICATE WITH THE WORLD.

YOUR STYLE WILL COME NATURALLY AT THE RIGHT TIME.

@MISSHUYENDINH

Panel 3:

Dear artists,

IT'S OK IF SOME ONE UNFOLLOWS YOU

IT DOESN'T MEAN THAT YOUR ART IS NOT GOOD.

IT DOESN'T MEAN THAT THEY DON'T LIKE YOU

IT JUST MEANS IT'S TIME TO MOVE ON

FOCUS ON THE PEOPLE WHO STAY

KEEP CREATING, MY FRIENDS!

@MISSHUYENDINH

Panel 4:

Dear artists,

YOUR ART MAY NOT CHANGE THE WORLD

BUT IF IT CAN CHANGE ONE PERSON'S DAY—

EVEN YOUR DAY—

IT STILL MATTERS.

KEEP CREATING, MY FRIENDS!

@MISSHUYENDINH

YOUR TURN

Here are some questions that you can ask yourself to figure out how to tell your stories through art:

What kind of stories resonate with you, either by mirroring your experience in life or by provoking your feelings?

Why do you want to tell this story now?

Who do you want to tell this story to?

What message are you trying to communicate to viewers?

What feelings do you want to evoke in your audience?

Once you figure out what story you want to tell, you can experiment with how you want to express it. Design elements like composition, color, line, symbolism, shape, and repetition will help you shape your story in your own way.

KEY TAKEAWAYS

 Everyone has a story worth telling. You just need to give yourself permission to tell it.

 You don't need to have everything all figured out at once. You just have to *trust the process.*

Your stories have power. Let them shine!

BEGINNER
greeting card

INTERMEDIATE
tote bag

ADVANCED
sneakers

Now that you have the foundation and have gotten a grip on breaking lettering rules, let's take things a step further and letter on different materials.

Together, we'll dive into three fun LIY projects—ranging from beginner to advanced levels—to turn your lettering into one-of-a-kind handmade items. You'll soon be able to make greeting cards, decorate your tote, and customize your sneakers. I promise it will get easier each time as you practice more.

To make it even easier for you, I designed the *Rule-Breaker's Markers* set, which you can use for all three projects in this chapter. These markers come in four colors and can be used to draw on multiple surfaces.

Let's get started!

BEGINNER LEVEL: GREETING CARDS 🌸🌸🌸

Handmade cards are a special way to show appreciation for your loved ones or yourself.

MATERIALS:

Cardstock paper or cards from the craft store

Pencil

The *Rule-Breaker's Markers* or any colored markers

Ruler (optional)

Scissors (optional)

Scrap paper (optional)

INSTRUCTIONS:

STEP 1: PREPARE THE CARD

Cut the size you want from the cardstock. In this tutorial, I used a blank five-by-seven-inch card from a craft store.

STEP 2: SKETCH YOUR LETTERING

Follow the creative process in chapter 6 to letter your quote: brainstorming, ugly sketches, and detailed sketch. You can do this either analog or digitally.

1. Brainstorming: I chose the message "You're cute and you deserve a break" because, in this fast-paced world, we often forget this and feel guilty about taking breaks.

2. Ugly sketches: Don't worry about being perfect here; the most important things are the letters' layout and proportions.

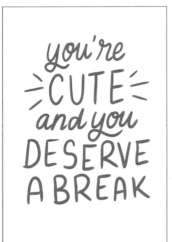
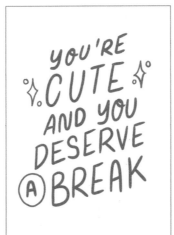
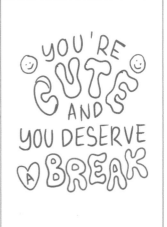

3. Detailed sketch: Pick one sketch and refine it.

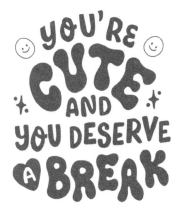

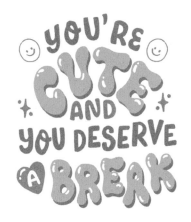

Optional: Plan out what colors you want to use for the final card either by hand or digitally. This is my digital version.

STEP 3: TRANSFER THE LETTERING TO THE CARD

Once you're happy with your layout, you can first lightly copy it onto the card with a pencil. Then trace over it with the colored markers.

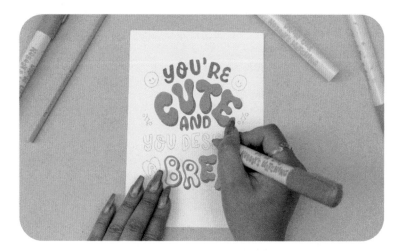

QUICK TIP:

If you're nervous about free-hand sketching, you can use one of these two tricks:

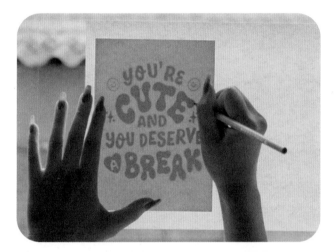

Trick 1. The window tracing method: Find a window with some light shining through it. Tape your sketch to the window. Place your cardstock on top and lightly trace with the pencil.

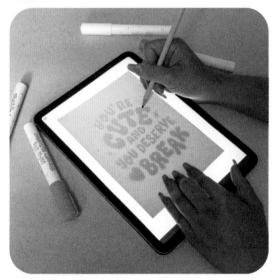

Trick 2. The digital device tracing method: Place your cardstock on top of your sketch on your device's screen and lightly trace with the pencil.

Ta-da! You have successfully made your first card. Now go write a lovely message inside, addressed to yourself or to whomever you would like to give this card.

INTERMEDIATE LEVEL: TOTE BAG

MATERIALS:

Blank canvas tote bag
(neutral or white is best)

The *Rule-Breaker's Markers* or
any fabric markers

Pencil

Black marker

Scrap paper (optional)

INSTRUCTIONS:

STEP 1: SKETCH YOUR LETTERING

Before jumping into drawing on the tote, let's stick with
the creative process from chapter 6.

I would choose a short quote or phrase, just two or three
words. Or you can letter the same phrase that I chose:
Emotional Baggage.

You can sketch in either an analog or digital way.

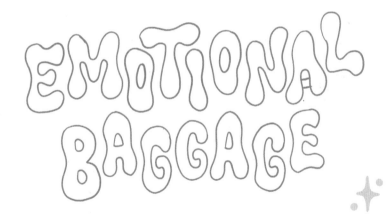

STEP 2: SCALE THE SKETCH

Analog option:

Once you have a miniature detailed sketch, take another piece of scrap paper and draw your lettering bigger, at the scale it will actually appear on your tote.

Quick tip: If you have a tablet, I have this trick for ya. Take a photo of your sketch and import it to your tablet. Enlarge the sketch on the screen. Then put the paper on top of the screen. Trace with a pencil.

Now you have a bigger version of your lettering on paper. Go over it with a black marker.

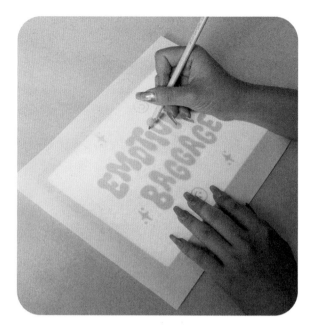

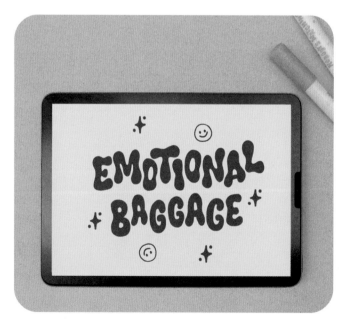

Digital option:

Change the sketch color to black so it is easier to trace in the next step. Enlarge it on the screen to the desired size by zooming in.

STEP 3: TRACE THE LETTERING ON A TOTE BAG WITH A PENCIL

Analog option:

Put the enlarged lettering paper inside the bag, with the right side facing the front of the bag, to see the sketch through the fabric. Then start tracing on the tote with a pencil.

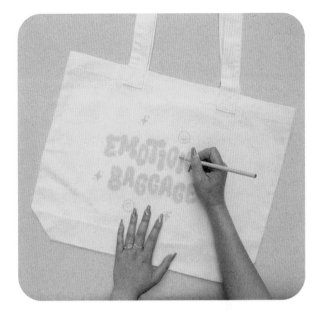

Quick tip: If the fabric is too thick and the sketch doesn't show through, no worries. Use the window trick from the card tutorial.

Digital option:

Put your digital device inside the bag with the screen facing the inside front of the tote where you want your design to be placed.

Adjust the screen brightness to the max and bring it to a room with dim light so the sketch shows better through the tote.

Trace the lettering with a pencil.

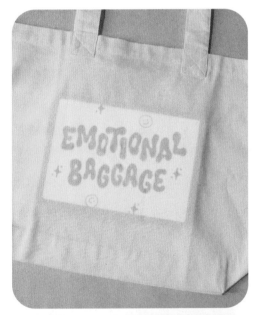

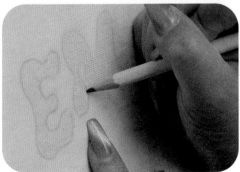

STEP 4: COLOR THE LETTERING WITH *RULE-BREAKER'S MARKERS*

You are now ready to decorate your tote.

To prevent ink bleed-through, insert a piece of paper inside the bag before coloring.

Fill or decorate the lettering with markers, moving from light to dark colors so it is easier to overlay the colors on top of each other.

Let each layer dry before you add another layer of color on top.

Add details to your lettering if needed.

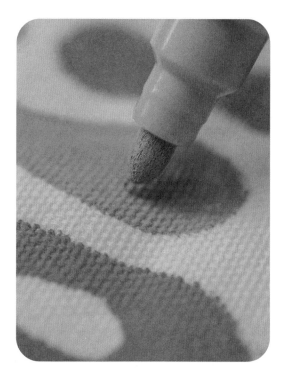

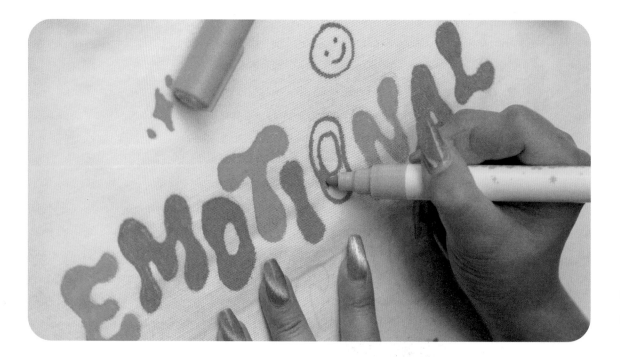

ADVANCED LEVEL: SNEAKERS

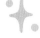

MATERIALS:

A pair of leather sneakers (white is best)

The *Rule-Breaker's Markers*

Nail-polish remover (100% acetone)

Cotton balls

Pencil

Eraser

Water- and stain-repellent spray

Scrap paper (optional)

INSTRUCTIONS:

STEP I: PREP YOUR SNEAKERS

White sneakers are best for customizing. Since we drew on canvas in the last tutorial, this is an opportunity to try a new material and draw on leather. I used a pair of white Nike Air Force sneakers.

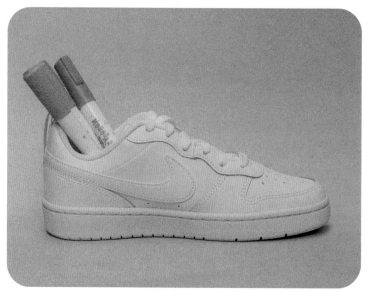

Quick tip: Take a photo of your sneaker or find a product photo online. You can either print the photo out and draw on top of it or sketch on top of the photo on the tablet.

Dip the cotton balls in acetone solution and wipe the shoes. This step is *crucial* because most shoes are covered with a factory finish—a clear coating that protects the shoes and will prevent the ink from sticking to the surface. I like to wipe the shoes at least three times to ensure they are clean.

Let them dry 30 minutes before drawing on them.

STEP 2: SKETCH YOUR DESIGN

While waiting for the sneakers to dry, you can start sketching on paper or a tablet, following the steps from chapter 6.

It's helpful to pick a theme and colors for your sneaker design. Mine is stickers and emojis.

STEP 3: OUTLINE YOUR DESIGN IN PENCIL ON THE SHOES

You can skip this step if you want to draw freehand with the markers on the shoes.

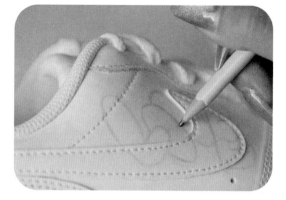

STEP 4: DECORATE SNEAKERS WITH THE MARKERS

Start filling in colors. If one layer of ink doesn't cover the surface, apply multiple layers.

Ensure the last layer is dry to the touch before adding another layer on top.

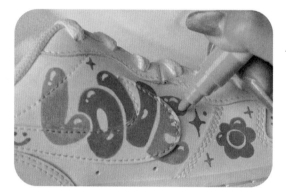

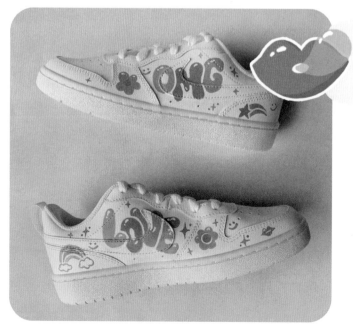

Quick tip: Fill colors from light to dark. You can use the white marker to hide any flaws.

STEP 5: APPLY FINISHER

After the ink is dry, use a water- and stain-repellent spray to protect the shoes.

Time to rock your new kicks.

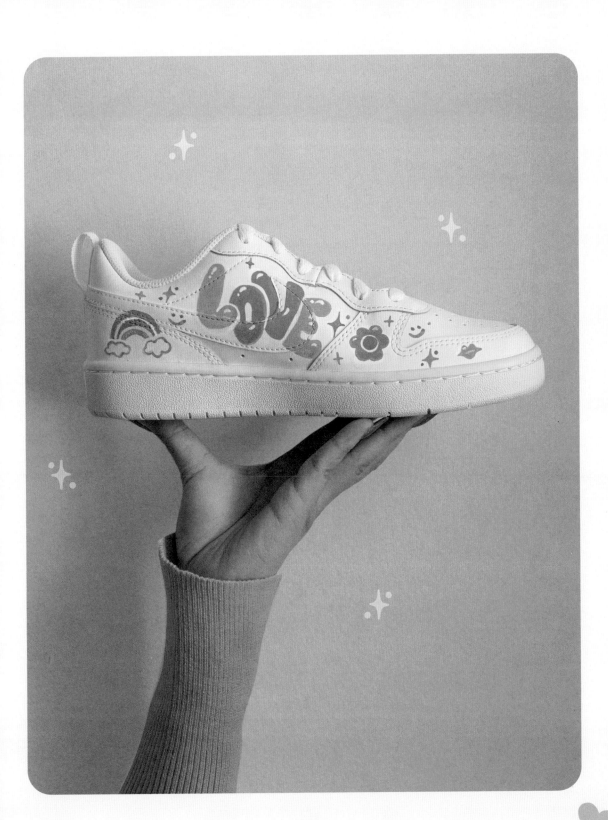

These are my favorite LIY projects, but don't be afraid to explore on your own and think of other unique ways to use your lettering.

DRAW LIKE NOBODY IS WATCHING!

ACKNOWLEDGMENTS

To everyone who helped make this book, in no particular order (I'm an overthinker, so please don't ask me to pick).

To the best accountability partner I could ever ask for, who willingly accepts all my imperfections: ME.

To YOU, my awesome reader, who I have never met but who allows me to be your cheerleader throughout your creative journey. I don't know you, but I love you, like seriously.

To my furry doggie, Bibo, who patiently stayed by my side the whole time when I read this book a million times to him.

To Belinda, my creative bestie and free therapist, who is always there to pick me up mentally.

To Ruby, my executive in-house assistant, who never gets her paychecks but willingly puts in the hours regardless to help my business.

To my family, my mom and my sister, who are always supportive of my dream and who made me the person I am today.

To all my lovely friends who already know who they are for supporting me in different parts of my life.

To my agent, Courtney, my publisher, Chronicle Books, and my editor, Mirabelle, who believe in me when others don't.

To all my internet friends, who have encouraged me and followed me since the beginning of my career.

And last but not least, to coffee; thanks for keeping me awake and keeping my creative juices flowing.